NORTHWEST *passage*

NORTHWEST *passage*

Photographs and Log by Robert Glenn KETCHUM

PREFACE BY WILLIAM SIMON

WITH COMMENTARY BY BARRY LOPEZ

APERTURE

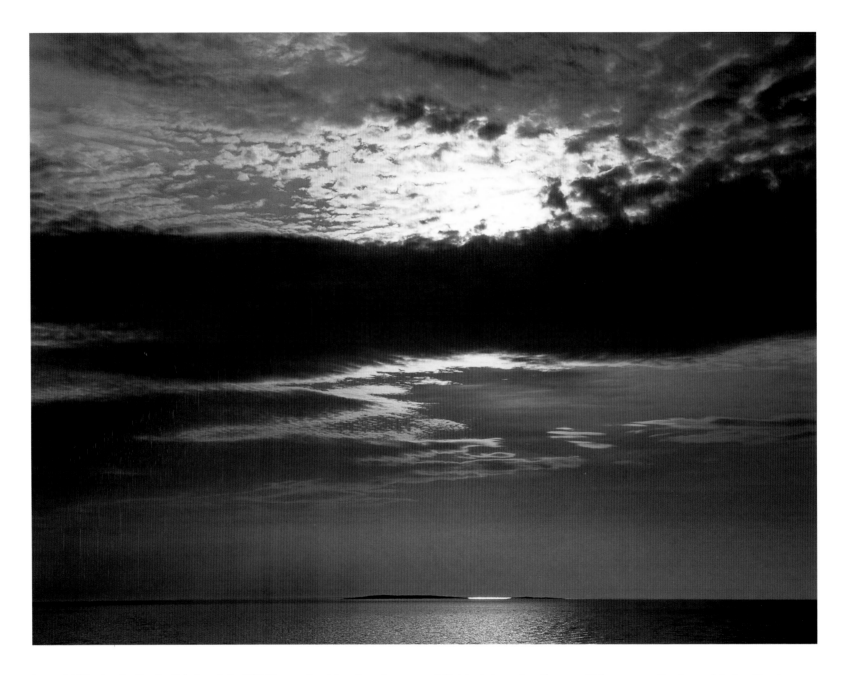

I would like to dedicate this book to **Bill Simon** for his adventurous spirit, his determination, and his generosity; I would also like to dedicate it to **Travis Gaard Ketchum**, who, like **Bill**'s ship the *Itasca*, represents a "true beginning" for me.

Sunset reflection "splits" two rebound islands.

Preface by William Simon, Expedition Leader

As early as the fifteenth century, explorers began searching the Arctic for an alternative water route from Europe to the riches of the Orient. Thousands of the world's best seamen were unsuccessful in this quest. Numerous ships and men were lost battling for the elusive "Arctic Grail"—the Northwest Passage. The most famous of these incidents was the ill-fated Franklin Expedition of 1845, comprised of two ships and one hundred thirty-nine men. All disappeared without a trace.

Finally in September 1906, the Northwest Passage was conquered by the Norwegian explorer Roald Amundsen, after a three-year effort on his ship, the *Gjoa*. Since Amundsen's historic voyage, there have been only fifty-five successful traverses of the Passage, in all manner of boats ranging from submarines to small sailing ships, which defied and conquered ice and fierce gales to make it through. On August 26, 1994 at 5:00 P.M., my ship, the *Itasca*, crossed the Arctic Circle, completing the very first single-season, west-to-east traverse of the Northwest Passage by a yacht. We accomplished this in twenty-three days and two-and-a-half hours, from Arctic Circle to Arctic Circle, beginning in Nome, Alaska, traversing Canada and the Northwest Territories, and concluding in Greenland.

For years I have been fascinated by the challenge and mysteries of the Arctic, and wanted to venture into the same areas as the great explorers: Cabot, Bering, Frobisher, Davis, and Amundsen. This voyage became my dream and then an obsession. Recognizing the dangers of the Passage—gale-force winds, unpredictable changes in the weather, the treacherous ice-pack floes that can crush a ship—only increased the allure of the adventure.

We began extensive strengthening of the *Itasca*'s bow and hull, and a helicopter pad was added on deck. She was outfitted with the most technologically advanced communications and navigational equipment available. Finally, the *Itasca* (the name derives from the Latin for "true beginning"), a 175-foot, 920-ton Dutch-built trawler, originally constructed in 1961 and converted to a motor yacht in 1983, was ready for the challenge. I believed she had the power, strength, and range to make the dream of crossing the Passage a reality.

While the refit of the *Itasca* was going on under the watchful eye of my friend and captain of ten years, Alan Jouning, I carefully chose a top-notch group to accompany me:

• Bill Langan, internationally known boat-designer and sailor, who won the Fastnet Race in 1993.

• Robert Glenn Ketchum, one of the most renowned naturalist photographers in the world, who was to document the voyage. The results of his work appear in this beautiful volume.

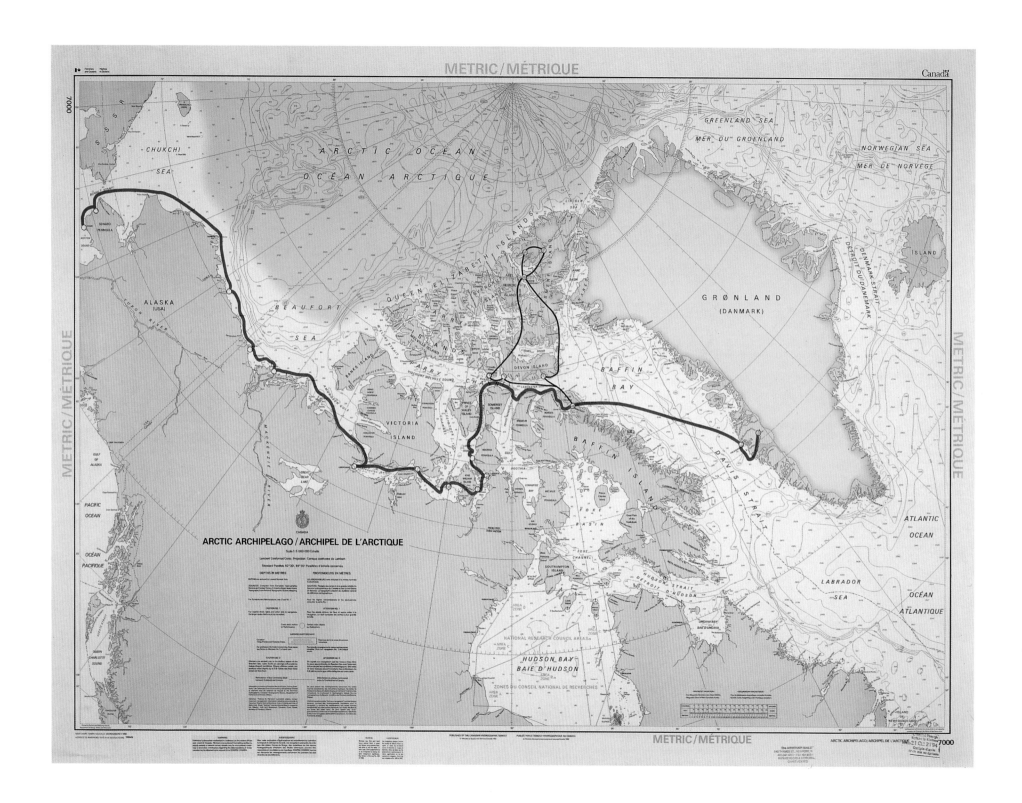

Map of journey: red line indicates water route; blue line to the north and back indicates flight of plane.

• John Bockstoce, Arctic historian and archaeologist, who had already traversed the Northwest Passage twice (on one of those trips, part of the voyage was undertaken in a walrus-hide umiak boat). He provided us with invaluable intelligence, not only in the planning of the trip, but in its execution.

• Doctor Robert Leach, orthopedic surgeon and chief doctor of the U.S. Olympic Committee.

• Doctors John Loret and Rita Matthews, prominent marine biologists, president and vice-president respectively of the Explorers Club, who would conduct an extensive study of the food chain and the migration of certain species from the Pacific to the Atlantic waters.

• George Gowen and Ettore "Barb" Barbatelli, two of my closest friends, who had accompanied me on several diving and sailing expeditions in the remote waters of the Pacific Ocean.

Most importantly, I was blessed to have Alan Jouning, the finest captain on the seven seas, at the *Itasca*'s helm. He and his fabulous crew enabled us to succeed despite occasional moments that tested our resolve, but not our determination.

No small part of this experience was the camaraderie shared by those aboard, each bringing his and her special strengths and insights to our adventure. In the end, eight strangers became friends who shared an unforgettable experience.

We chartered a helicopter during the voyage to scout routes through the narrow openings in the ice packs ahead and treacherous shoals of uncharted waters. En route, we landed on many islands that have seen few if any human beings. The helicopter also made it possible for Ketchum to photograph rare views of the variegated topography of the Northwest Passage, and all of us enjoyed the spectacular views and regular encounters with caribou, musk ox, polar bears, whales, and tens of thousands of birds. These magnificent photographs capture the beauty of this wild place, and document the *Itasca*'s journey through the Arctic ice.

Over many years of adventures—sea-diving, sailing, cruising above and below the water in areas seldom if ever visited—I have had some unforgettable experiences. But the privilege to lead this historic expedition through the Northwest Passage, pictorially recounted here, is unrivaled by any other adventure I have had thus far.

To my shipmates and me, it was the adventure of a lifetime, filled with danger and excitement, and with scenes of indescribable natural beauty. For those who could not accompany us across the Arctic, this book provides a vivid sense of all that we saw and felt as we made history through the Northwest Passage in the summer of 1994.

Temporarily abandoned Inuit fishing hut, Somerset Island.

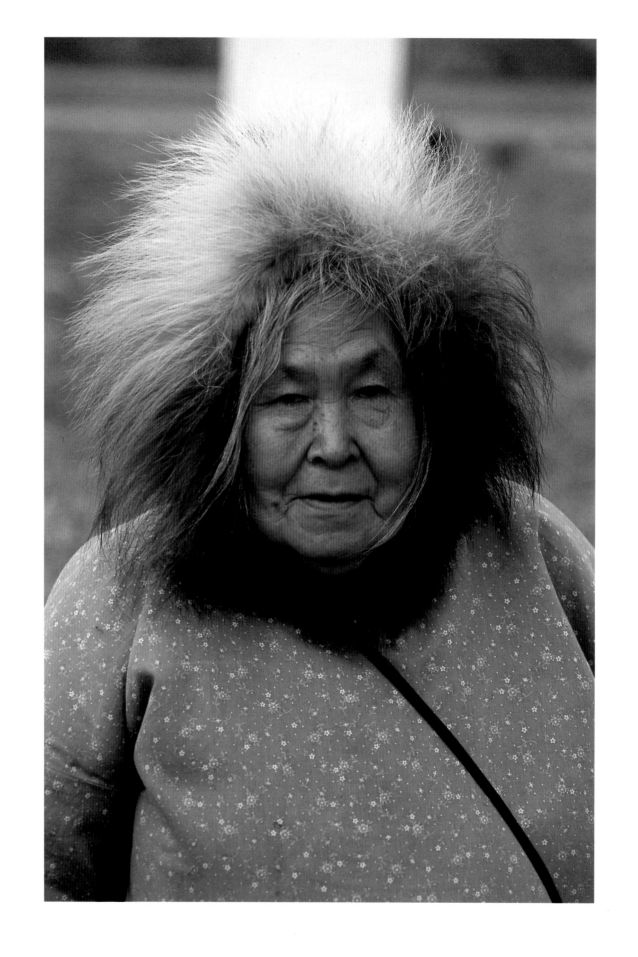

M.V. ITASCA Journey Through the Northwest Passage

Excerpts from Robert Glenn Ketchum's Ship's Log

SATURDAY, *July 30, 1994:* Flew from Juneau to Nome via Anchorage. We'd been told in Anchorage that we probably wouldn't be able to land in Nome because of the weather conditions, but it cleared briefly, and we were able to touch down at about 6:45 P.M. The *Itasca*'s captain Alan Jouning, and first mate Colin McKay met me at the plane. We drove to the dock and boarded a Zodiac for transit out of the small harbor, to where the *Itasca* was anchored in the open ocean.

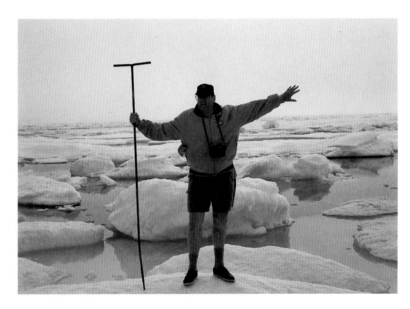

SUNDAY, *July 31:* Awoke to a hard rain and ceiling near zero. Wind has picked up, and the *Itasca* is beginning to swing at anchor. By 10 A.M., a swell is building and we are taking large waves—the external decks are flooding with each hit. Nome is barely visible. Waves increase in size throughout the day, and walking around on board reminds me of pinball.

In the evening, when I go to bed, I find that sleep is impossible. The boat is pitching so much that it is hard to stay in bed, so I go to the upper salon. At about midnight, a wave breaks against the window there—two decks above the waterline.

MONDAY, *August 1:* At about 4 A.M. it becomes even nastier out, and the rolling throws all standing objects to the floor. Books and videos fall out of shelves, whole drawers in the galley are blown out of their rails, and my bathroom mirror is ripped off the wall. The ship begins to drag at anchor, so Alan awakens the crew, they hoist it, and we navigate directly into the storm, away from Nome and the rocky coast.

Bill Simon and the other guests are due to arrive in Nome at noon, but there is no chance that we will be able to pick them up, so the *Itasca* will head north about ninety miles, to Port Clarence, a more protected harbor where we can load. Once we turn aside of the storm, the fury of the waves increases dramatically, and as the day progresses, the swells keep getting bigger. We have reports from boats to the north in the Bering Sea that out there they are at twenty feet and more. Alan decides to wait out the rest of the storm in the shelter of the port and make repairs.

John Bockstoce as Moses, parting the ice, Cape Victoria. Photograph by M. William Langan.

Elderly Inuit woman in traditional parka, Herschel Island. Photograph by Max Cumming.

TUESDAY, *August 2:* Port Clarence is calmer, and early in the morning, Bill and the others are brought on board. Remarkably, the crew has managed to clean up the boat except for the most severe damage. Repairs are made throughout the day, and the weather continues to improve.

At about 8:30 P.M., some of us go ashore, carried to a shale beach by the Zodiac. From there, we climb, using a small stream of waterfalls as a staircase, until we reach the tundra. Very little grows above a foot high here, but there are wildflowers blooming and small shrubs, and the ground is covered with lush moss and lichens. Walking is difficult, because with each step we sink deep into the cover.

Eventually, finding frozen bare ground upon which I can walk, I decide to climb higher, and along my route I encounter quite a lot of reindeer scat. As I reach the brow of the ridge, the ceiling lifts, and a wonderful view opens up: small holes of sunlight dance across the landscape and help to define miles of rolling hills covered with tundra. It is absolutely silent, except for the sound of the cooling breeze.

About 9:45 P.M., I rejoin the group below. On board the Zodiac to return to the *Itasca*, we follow the coastline for a short distance, and catch sight of an arctic fox watching us from the crest of the bluff we just climbed down.

WEDNESDAY, *August 3:* The storm backed off completely during the night, so this morning we hoist anchor and run due north to Barrow in a nearly straight shot. Later in the day, when we cross the line of the Arctic Circle, the water is incredibly glassy. Both the sky and the ocean are clear, but a thin fog hides the horizon-line.

By evening the temperature has dropped, but as I complete this entry, at 11:30 P.M., the sun is still quite bright through the fog. I do not think it will set tonight.

THURSDAY, *August 4:* About 8 A.M., we round Cape Lisburne and turn slightly east toward Icy Cape and Barrow. The water has grown darker, but there is no ice so far.

Off the bow, we spot two walrus, and toward evening we come to an area that must offer prime feeding for them, as hundreds more surface around us to observe the boat passing.

The water is extremely clear, and from the bow we can see thousands of jellyfish float by. If you consider the water from here to the horizon, you realize there must be *millions* of them.

FRIDAY, *August 5:* This morning, we encountered the first of the ice. There is no defined edge, and most of what is in front of us is in pieces through which we can navigate. Bergs vary in size, some like small islands. A sea-level fog causes the ice to appear, phantomlike, out of the haze. At times it is so blindingly brilliant that it is impossible to look into. Photographically, these are some of the most extreme conditions I have ever faced.

Gigantic iceberg dwarfs cargo freighters unloading at Pond Inlet.

After rounding the point at Barrow, the edge of the ice grows closer, and we navigate nearer to the shore in shallower water. It is like working through a maze, trying to figure out where the open holes will lead and whether we can get through. All the while everything is drifting and shifting. To make things more confusing, mirages appear in many forms, with absolute clarity. Even through binoculars, false "glaciers" seem as real as any other part of the landscape—but in fact, there is only sea ice, floating flat on the water.

As the evening wears on, the air becomes crystal clear, and the definition of the floes against the color of the sea makes them even more dimensional. Glacier-mirages take on the warm glow of late light, and the sun shines off the water with starlike reflections.

SATURDAY, *August 6:* We are just off Prudhoe Bay. As the ice coverage increases, we must pass over an extremely shallow bottom, less than a fathom (seven feet) beneath the boat. We have had some contact with large ice, and the impact jars the ship, reverberating loudly through the hull.

The day is marked by particularly strong mirages, including one that is visible for hours: a thin, black cloud parallels the horizon, and hanging upside-down between it and the sea are the buildings of Prudhoe Bay—now well past the horizon. The mirage contains every detail, including moving trucks and flare fires burning in the background. Later in the evening there appears another: a causeway bridge, complete with steel trestles and a superstructure.

SUNDAY, *August 7:* The pack is still shifting, but we lift anchor and work our way through it toward Herschel Island. As we near Barton Point, the ice virtually disappears, and the weather begins to change. Within two hours' time, dark clouds obscure the Brooks Range, which had been clearly visible for quite a while. As the storm develops, the mountains disappear and reappear, and the clouds are a dense purple. Lightning and squall lines can be seen against blue-gray curtains of rain. Slowly, the weather spreads toward us. As the storm builds in intensity, the wind picks up.

Then, one of the strangest things I have ever seen occurs. A gray cloud has formed across the entire horizon behind us. It seems to start just above the mountains and roll up into the sky, covering a quarter of it. As it becomes more turbulent, one end of the cloud takes on the appearance of a corkscrew. It grows before our eyes, rolling toward us. Langan yells from the bridge that it is a cold front, packing thirty- to forty-mile-per-hour winds, which will soon run us down. Almost immediately, the wind turns fierce, and the cloud wave is upon us. Blocking out the sky, it batters us with huge raindrops and hail. Then, as quickly as it came, the cold front is gone. The wind dies down and the water is calm. Broken sunlight filters through the clouds once again, and lights up the ocean and the ice. Ahead of us, the front rolls on, causing bizarre light and creating ocean waves. All of this takes place in less than five minutes.

Musk ox skull and skins among discarded shipping containers, Gjoa Haven.

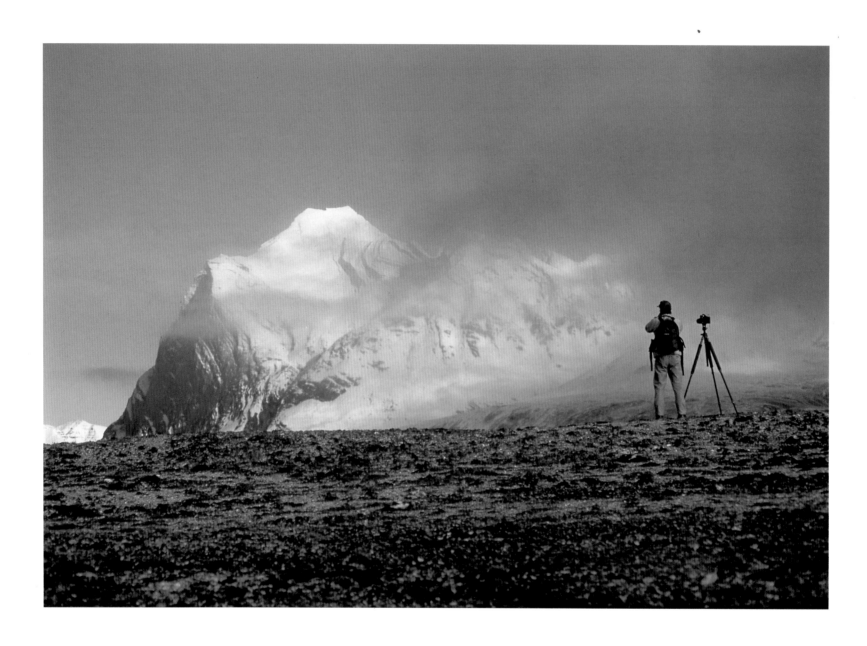

Ketchum at work, Otto Fjord, Ellesmere Island. Photograph by Robert Leach.

MONDAY AND TUESDAY, *August 8, 9:* Visits to Herschel Island and to Tuktoyaktuk, in the Canadian Northwest Territories, where we pass through customs. "Tuk" sits near the mouth of the Mackenzie River, whose "warm" waters help keep the area relatively ice-free. This won't last long, though. Here, we pick up registered ice-pilot Bruce Brophy who will help us navigate in the days ahead.

WEDNESDAY AND THURSDAY, *August 10, 11:* We are now traveling in very open waters, as we are finally in the protective "shadow" of the big islands in the Arctic Archipelago. We traverse the Amundsen Gulf and the Dolphin and Union Strait, and enter Coronation Gulf. Along the way, basalt islands offer vertical relief in the landscape.

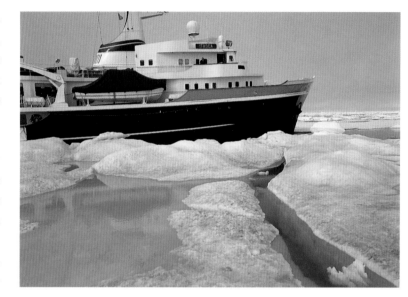

At about 7:30 P.M., we reach the small Inuit village of Coppermine, where we drop anchor and all go ashore. Many families are fishing offshore—there is a run of Arctic char. Incredibly, as we approach the beach, there are children swimming in the freezing water. We walk around town a bit, and I make as many pictures as I can, moving from one location to another. Every yard has three basic objects: a sled, a snowmobile, and a four-wheel-drive ATV. Children are everywhere, and tag along asking to be photographed. At 10 P.M., a curfew siren calls them home, as it is a school night.

We return to the *Itasca* and start for Cambridge Bay.

FRIDAY, *August 12:* As we pass through Dease Strait, the weather begins to change, and by evening, the sky is occluded. The islands around us are once again low and flat. From close up, they look like striated deserts; they are marked with perfect horizontal lines from their shores to their summits. These are tidal ice rings. The islands were originally under the ice cap, and as the ice melted and became lighter, the islands "rebounded," rising by increments. Seasonal sea ice created the visible ridges on the shorelines.

We reach Cambridge Bay about midnight. Despite the hour, it is still quite light and not too cold. We decide to visit the historic wreck of one of Roald Amundsen's boats, the *Maude*. She lies at one end of the bay with about a quarter of her deck above water, and much of her ribbing exposed—she has been well-preserved in the Arctic waters. It is a ghostly scene, but settled in the dark water against the sunset and the spare hills, the *Maude* is beautiful.

SATURDAY, *August 13:* The helicopter arrives this morning. Though the wind is blowing hard and the boat is swaying, the pilot manages to bring it in to the back of the top deck.

The Itasca *briefly trapped in the ice of the James Ross Strait.*

The ice reappears, now with a new color. The floes we passed before were relatively "new"; they contain a lot of salt, which gives them an emerald-green coloration. The older ice we are now encountering is pale blue—the sea salt has been leached out of it by melting and rainfall. This ice is more dense and hard. Pools trapped in the center of these floes are freshwater and drinkable.

SUNDAY, *August 14:* After a morning stop to the Inuit village of Gjoa Haven, we return to the *Itasca* and head north, around the Gibson Peninsula, toward Cape Victoria. Bockstoce and I are the first to scout, in the smallest helicopter I've ever been in.

Once we lift off, the magic of being in the air takes over. What we have seen on the maps is now before us: thousands of lakes, landlocked on the low, flat islands spreading to the horizon. Between them, the tortured tundra alternates between vegetation and wild frost cracks forming amazing patterns. This is a view that no historic Arctic explorer ever had—the aerial perspective.

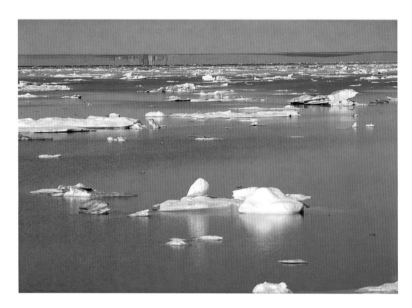

We fly due north across La Trobe Bay, Cape Norton, and the Beverly Islands. As we cross Matty Island and Wellington Strait, it dawns on me what the real Arctic is like. Ahead lies the James Ross Strait, entirely choked with ice. The floes are shoulder-to-shoulder and shore-to-shore. It is breathtaking. It is also impossibly dense, and there are few leads, if any, for the *Itasca* to ply. This is the crux point of our trip: we must round Cape Victoria to go north, or we will have to turn back.

MONDAY AND TUESDAY, *August 15, 16:* We start out early in a light rain. An apparent lead opens up near the shore of the Boothia Peninsula. We follow it and make good progress, but soon enough it ends. The helicopter goes out to scout and comes back with a report that there are no more leads.

We begin to push into the pack by force of motor, and eventually inch our way around Cape Victoria. Here we find ourselves confronted by a large pressure ridge and some serious shallows to navigate through. We continue to push the pack, attempting to make headway. This ice is old and dense, and the *Itasca* is not an icebreaker, so we have anxious hours as the boat creeps forward. The lead has closed behind us; there is no going back.

It rains hard most of the night, and an unfavorable north wind builds in strength. The *Itasca* continues to move forward until about 1 A.M., when the constant roar of the thrusters and the banging of the ice hitting the hull becomes so unrelenting that Alan decides to shut the boat down so everyone can sleep.

In the morning, the pack has closed even more tightly around us, and we have lost ground by drifting within it several miles south, closer to shore. There is a possibility that we could be pinned against the shore, or end up in water too shallow to be rescued by a larger boat, so Alan once again begins to move the *Itasca* slowly forward.

Complex mirage of thin, dark clouds and Prudhoe Bay buildings upside-down. Beaufort Sea.

WEDNESDAY, *August 17:* There is some clearing in the weather, but not the ice. We are still at least sixty miles from the next determinable open water, and each night the pack carries us back as far as we have progressed.

The Canadian Coast Guard, which has been tracking us, sees that we are not moving much, so they radio that they are sending in an icebreaker, the *Sir John Franklin.* The ship arrives out of a fog, like a vision. Their captain tells us that we are out of our league in the *Itasca* here, and that there is impenetrable ice ahead. Clearly, he would prefer to lead us back through the strait to Gjoa Haven.

Bill Simon, however, is determined. He phones the captain of the icebreaker to say that as the owner of the *Itasca* he is willing to take the chance. The captain thinks about it for an hour, and then gives us liability release forms to sign. We plan to proceed in the morning.

THURSDAY, *August 18:* Near dawn, the icebreaker leaves, and the *Itasca* runs behind in its wake for several miles, hoping to make up for lost time. The icebreaker is a large boat—over 400 feet—and its thrust creates a river torrent. Into that wake of white water, huge pieces that have been broken off are thrown back at us. The *Itasca* takes a beating, sometimes being lifted out of the water by floes it strikes.

The *Sir John Franklin* eventually turns off our course, and we part ways. We have reached somewhat open waters, but by evening the weather is changing again, and around 4:30 A.M., the *Itasca* is once more pushing ice.

FRIDAY AND SATURDAY, *August 19, 20:* Early this morning, we see a polar bear sleeping on one of the nearby floes. When our engines wake him, he moves away, from floe to floe, swimming in the cold water between. We are seven miles from land, yet he seems perfectly at home.

We go out on a recon flight over the shoreline of Prince of Wales Island. There we see pods of beluga whales feeding. We start a general count: there are six to ten whales in a pod, and as we fly we see hundreds of pods. In the clear blue-green water, the pale bodies of thousands of whales are luminous.

The following day, we traverse Peel Sound and turn into Barrow Strait, paralleling the north shore of Somerset Island.

The weather clears enough to go out in the helicopter and investigate. Prince Leopold Island is particularly dramatic with its vertical, walled shoreline and huge bird rookery. Late in the day, we lose sight of the *Itasca* as an evening fog moves in rapidly. We have to work our way back by sight. Upon our return, it begins to snow.

SUNDAY, *August 21:* From the helicopter this morning, we can see that there is open water within a mile. We radio the *Itasca* to head for it, and then do some "flightseeing," following the coastline of the Brodeur

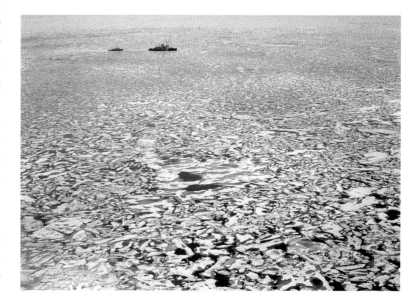

The Itasca *in the wake of the Canadian icebreaker, the* Sir John Franklin*, navigating dense ice coverage in Larsen Sound.*

Peninsula of Baffin Island. This is a succession of valleys and mountains whose summits rise 1,800 feet from the rock-strewn coastal plane. Fierce canyon winds make flying erratic and difficult.

By the time we return, the *Itasca* has reached open water and the storm has blown away.

MONDAY, *August 22:* Through Navy Board Inlet, we arrive at the village of Pond Inlet. The surrounding waters are relatively open, but this is the first time we see large icebergs among the sea ice; these bergs have been calved from the glaciers that reach tidewater in this harbor. There is more vegetation on the land here, indicating the warming influence of the Atlantic, now nearby.

Today, we'll take a small detour. The *Itasca* will go no farther north; she will navigate east to Greenland and then south toward North America, so we will all take a small airplane as far north as we can go—perhaps as far as Eureka or Alert.

The plane lands briefly at Beechey Island and then at Resolute. Although the pilots have predicted very poor visablility, it is a gorgeous, clear day. I spend it making pictures: Axel Heiberg and Ellesmere Islands have fresh snow on their summits, and golden late light is everywhere.

As we land at Eureka, there are musk oxen on the runway, and arctic hares everywhere. This is the second-highest-latitude manned base in the world (at lat. 80°00'N, long. 85°56'W). After dinner at the base, around 11:30 P.M., I go for a walk under the bright skies, and see more hares and musk oxen, as well as lemmings and a white wolf.

TUESDAY, *August 23:* We fly early today, pushing farther north, and land on the beach of Otto Fjord. This is as far north as we will go. The fjord has sea ice, but it also has an active glacier at its head, calving tremendous icebergs into the channel; they rise hundreds of feet above the water.

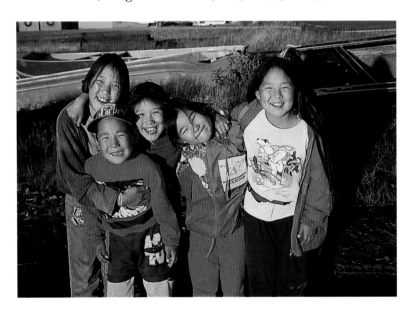

The flight back to Pond Inlet remains almost entirely clear, crossing from Ellesmere over Jones Sound. We traverse the broad expanses of several glaciers on Devon Island, then pass over the intensely blue waters and floating ice of Lancaster Sound. Lastly, we cross the summits and ice fields of Bylot, before we arrive again in Pond Inlet.

Back on board the *Itasca*, later in the evening, we navigate toward the strait that will take us to Baffin Bay. The rugged shoreline lingers for hours—the final view of the North American Arctic on this voyage.

WEDNESDAY AND THURSDAY, *August 24, 25:*
The two-day passage across Baffin Bay is made in clear weather, with a fierce, wind-driven ocean that pitches the boat wildly. Icebergs the size of small cities drift by us, most likely calved by the tremendous glaciers of

Inuit children playing in the warm late light of evening, Coppermine.

Greenland. As they float in the black waters, the light of the full moon gives them an ethereal glow.

FRIDAY, *August 26:* In the morning we stop at the lovely village of Holsteinsborg—or Sisimiut as the Greenlanders refer to it—and by noon we are back on board the *Itasca*. We are nearing the imaginary line of the Arctic Circle. The sun left us when we left port, and the skies have become clouded with fog. At the actual compass crossing of the Arctic Circle line, we assemble on the bow for a group picture, and then celebrate with a small party.

Traveling west to east—against tradition—we have accomplished the first single-season, private boat traverse of the Northwest Passage in history. Ours is most likely the fastest traverse ever as well, because we were able to run nearly twenty-four hours a day, in excellent conditions.

We are sailing south for Sondre Stromfiord—a fjord over 100 miles long—at the end of which we will be met by an airplane to take us home. As we enter the fjord, darkness is falling—we are now further south, and the days of endless light are behind us.

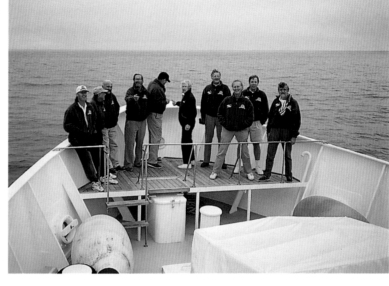

The skies have cleared, and after dinner I go out to watch the moon rise. It is nearly full, and silhouettes the fjord walls, illuminating streams of low fog. On the far horizon, I can see the first faint lights of an aurora display, so I call everyone to the deck. By the time they gather, the illumination has become brighter, moving up the fjord, encircling the mountains around us. The colors intensify as the display bridges the sky directly overhead. It seems to ripple and sway, like a curtain, and then draws into itself, consolidating at a central point and bursting out in waves of light. Other curtains form around us, and rays beam skyward from behind the surrounding mountains. The show continues well into the night, but most of us eventually retire to ponder this final spectacle of our voyage. An extraordinary conclusion.

Simon and guests celebrating on the bow of the Itasca *as they cross the Arctic Circle, Davis Strait near Greenland (from left to right: Ketchum, Loret, Jouning, Simon, Bockstoce, Matthews, Barbatelli, Leach, Langan, Gowen).*

Bill Simon, never doubtful. Photograph by John Bockstoce.

... Beginning in a time before the sagas, the notion of a road to Cathay, a Northwest Passage, emerges. The quest for such a corridor, a path to wealth that had to be followed through a perilous landscape, gathers the dreams of several ages. Rooted in this search is one of the oldest of all human yearnings—finding the material fortune that lies beyond human struggle, and the peace that lies on the other side of hope.

Arctic history {is} for me ... a legacy of desire— the desire of individual men to achieve their goals. But it {is} also the legacy of a kind of desire that transcends heroics and which {is} privately known to many—the desire for a safe and honorable passage through the world.

The excerpts on this and subsequent pages are from the book Arctic Dreams, *by Barry Lopez.*

In a dead calm under clear skies, a water-level fog creates a horizonless ocean.

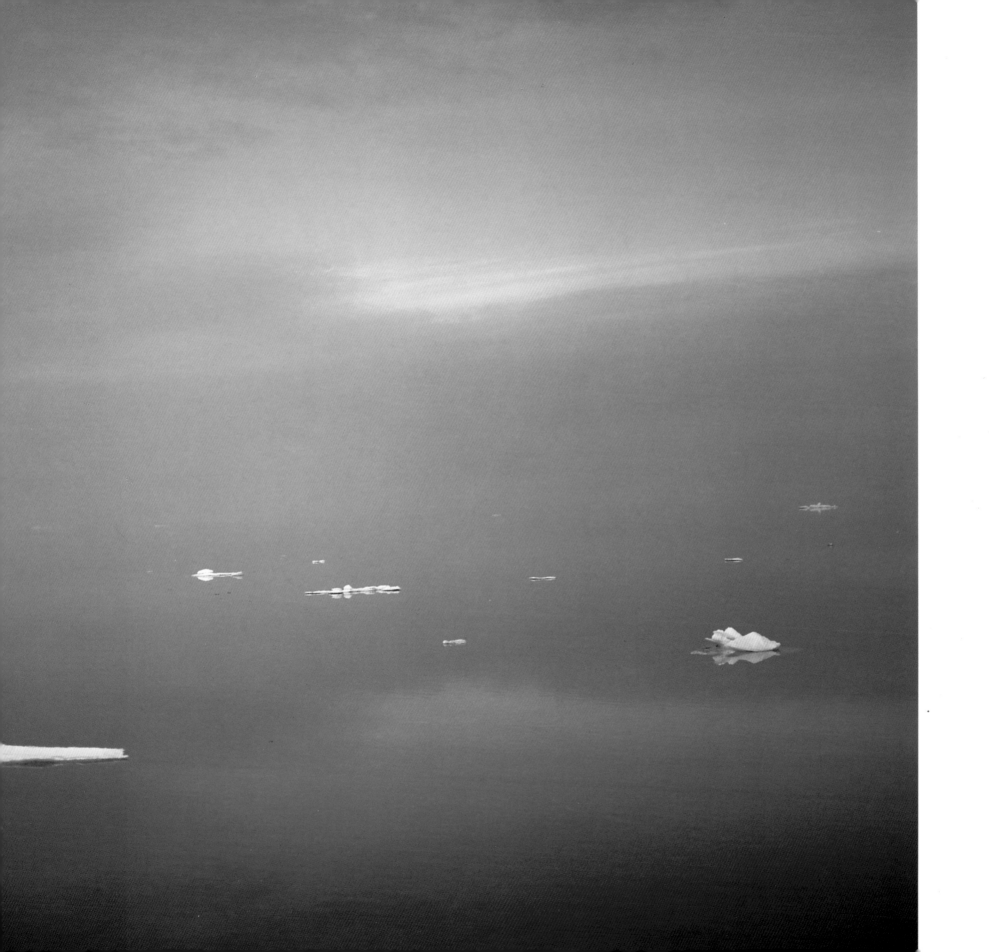

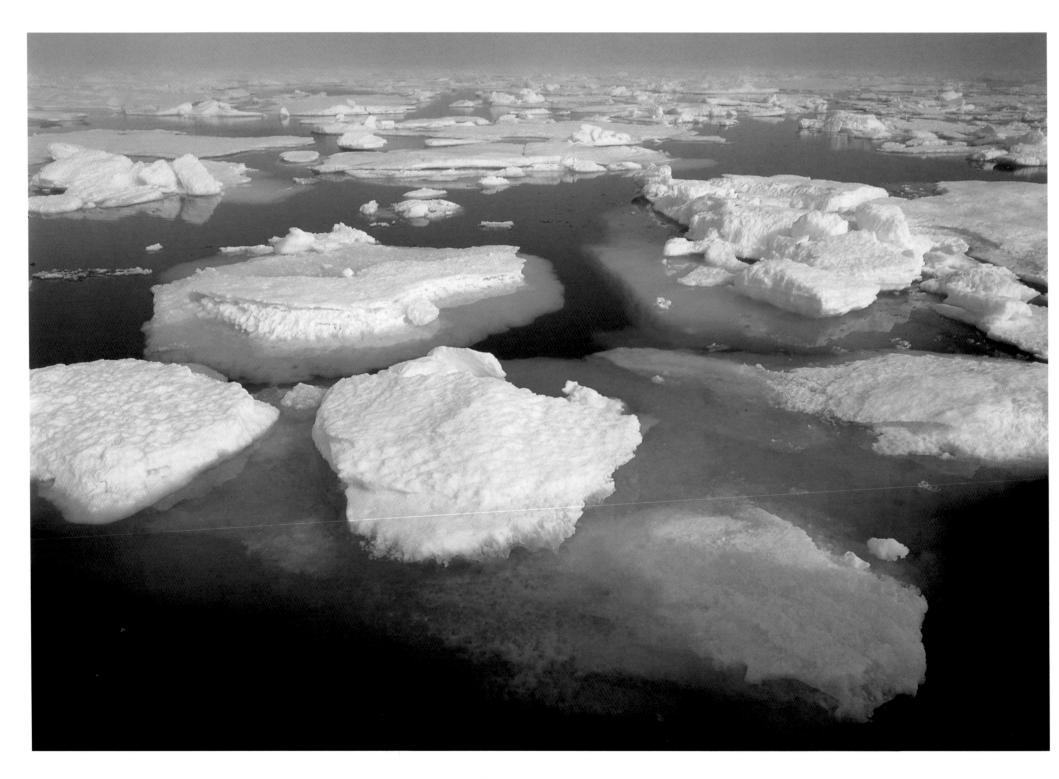

Beneath a thin fog, early morning sunlight illuminates extensive ice coverage.

Extremely thick multiyear ice encountered in the James Ross Strait.

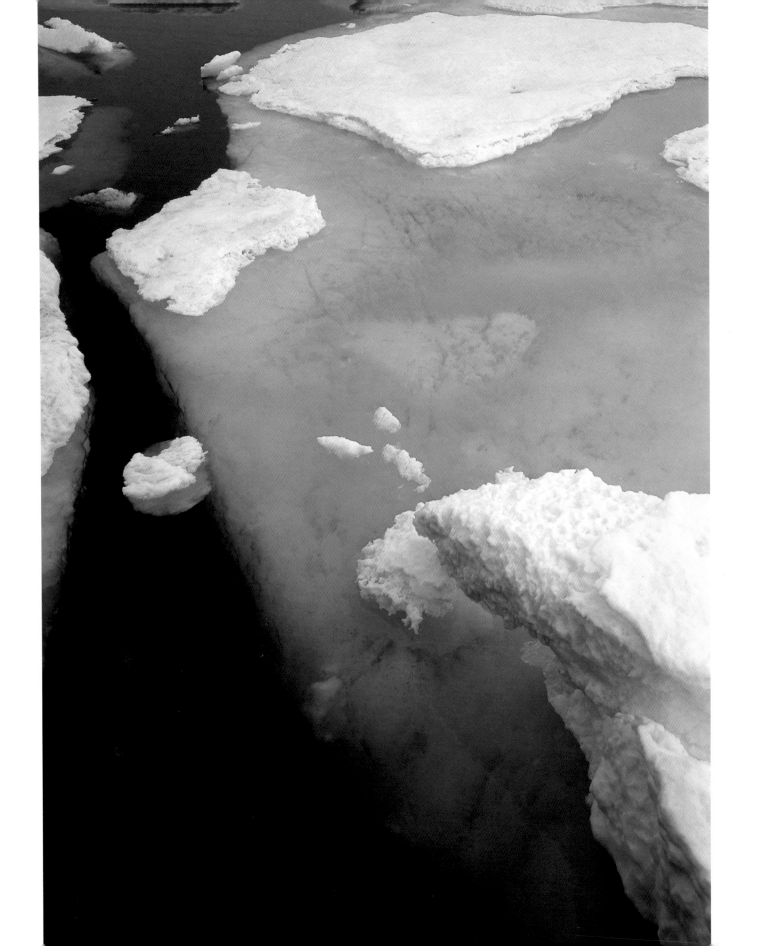

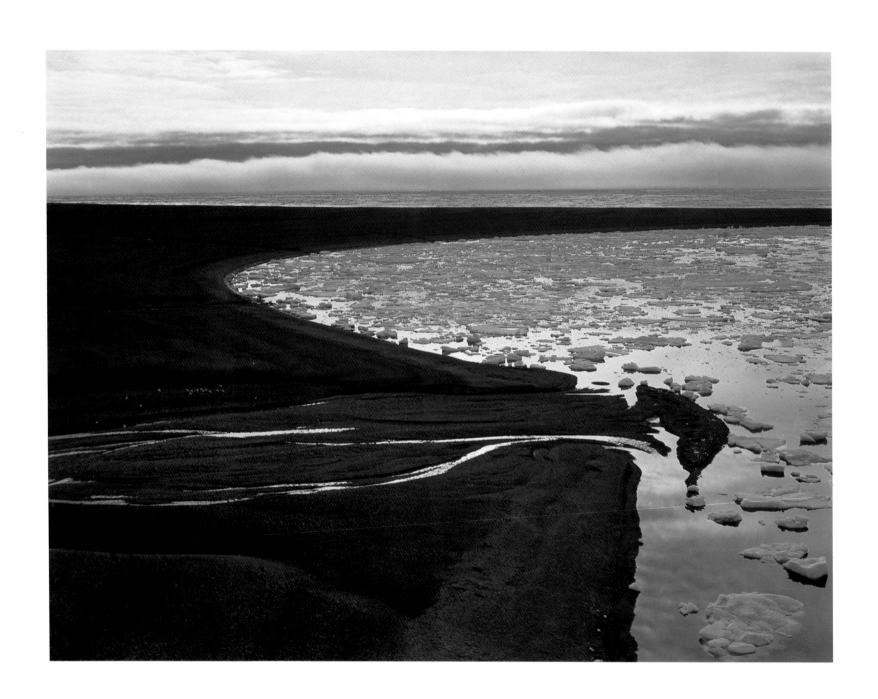

"Bergy bits" along the shoreline of Prince Leopold Island.

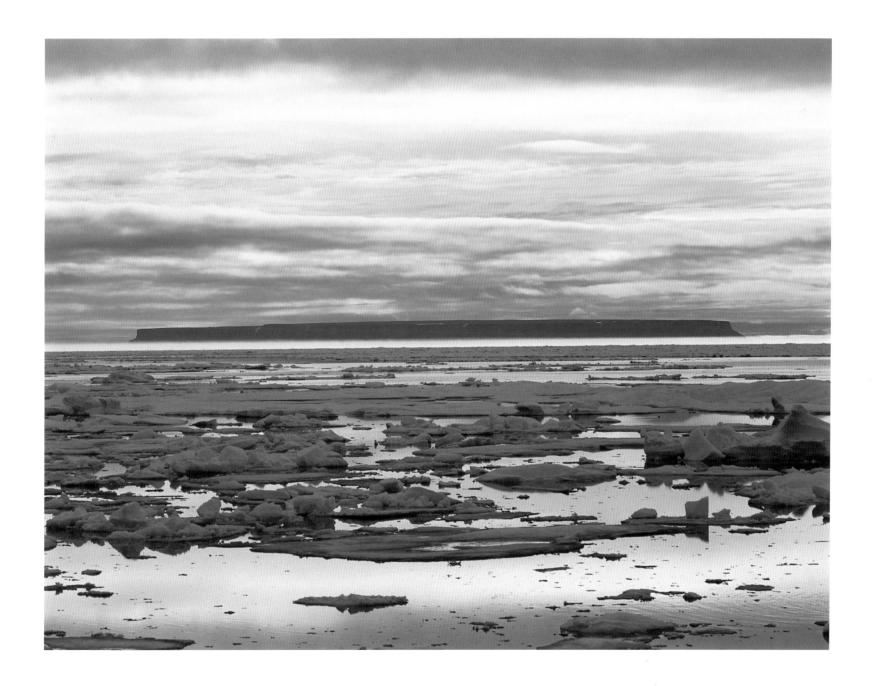

Prince Leopold Island appears to float in a band of early-morning fog, the Barrow Strait.

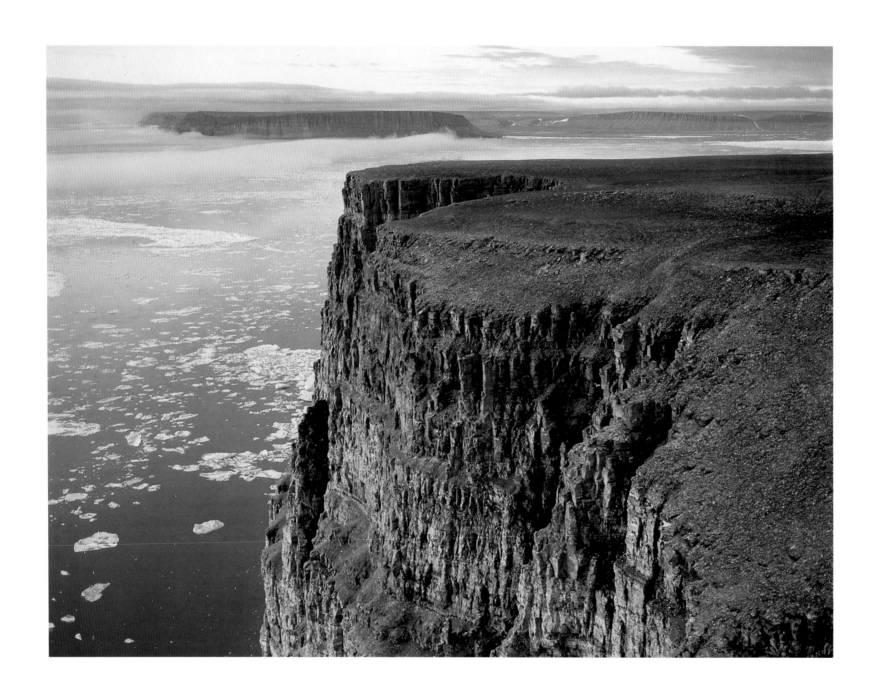

The vertical shoreline cliffs and bird rookeries of Prince Leopold Island. View is across the Barrow Strait toward Somerset Island on the perimeter of the biologically rich Lancaster Sound.

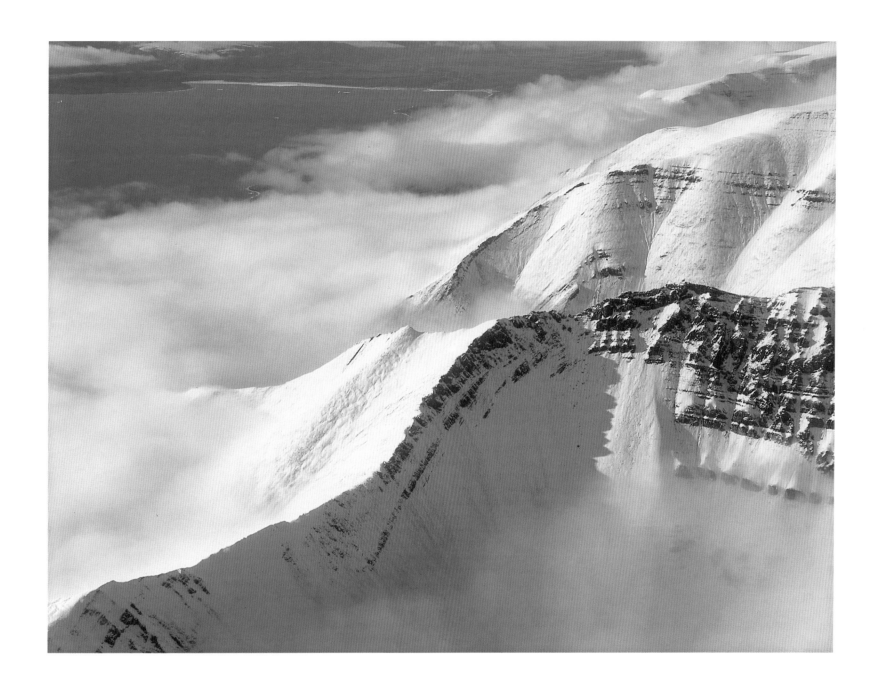

Snowcapped mountains, Axel Heiberg Island.

It is possible to travel the Arctic and concentrate only on the physical landscape—on the animals, on the realms of light and dark, on movements that excite some consideration of the ways we conceive of time and space, history, maps, and artBut the ethereal and timeless power of the land, that union of what is beautiful with what is terrifying, is insistent. It penetrates all cultures, archaic and modern. The land gets inside us; and we must decide one way or another what this means, what we will do about it.

Sea ice grounded in the shallow, clear water around a rebound island, James Ross Strait.

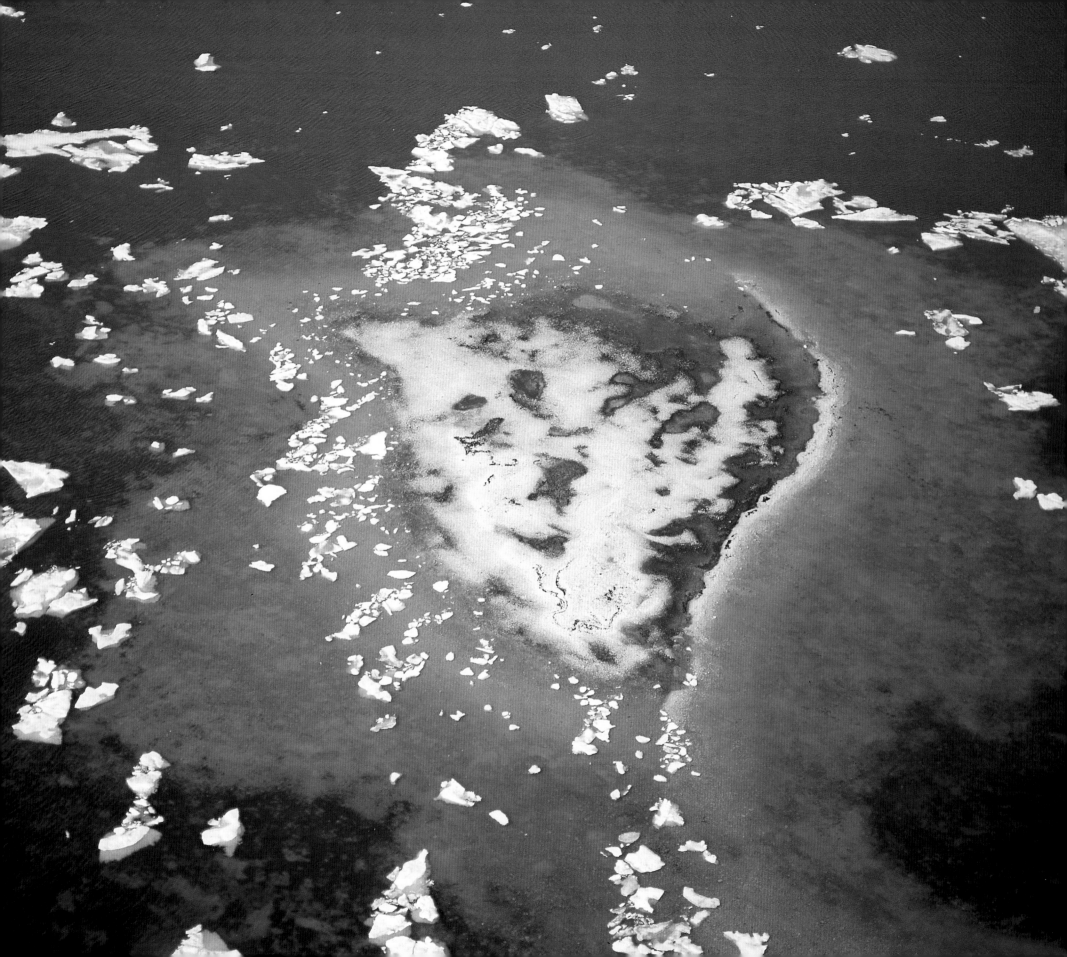

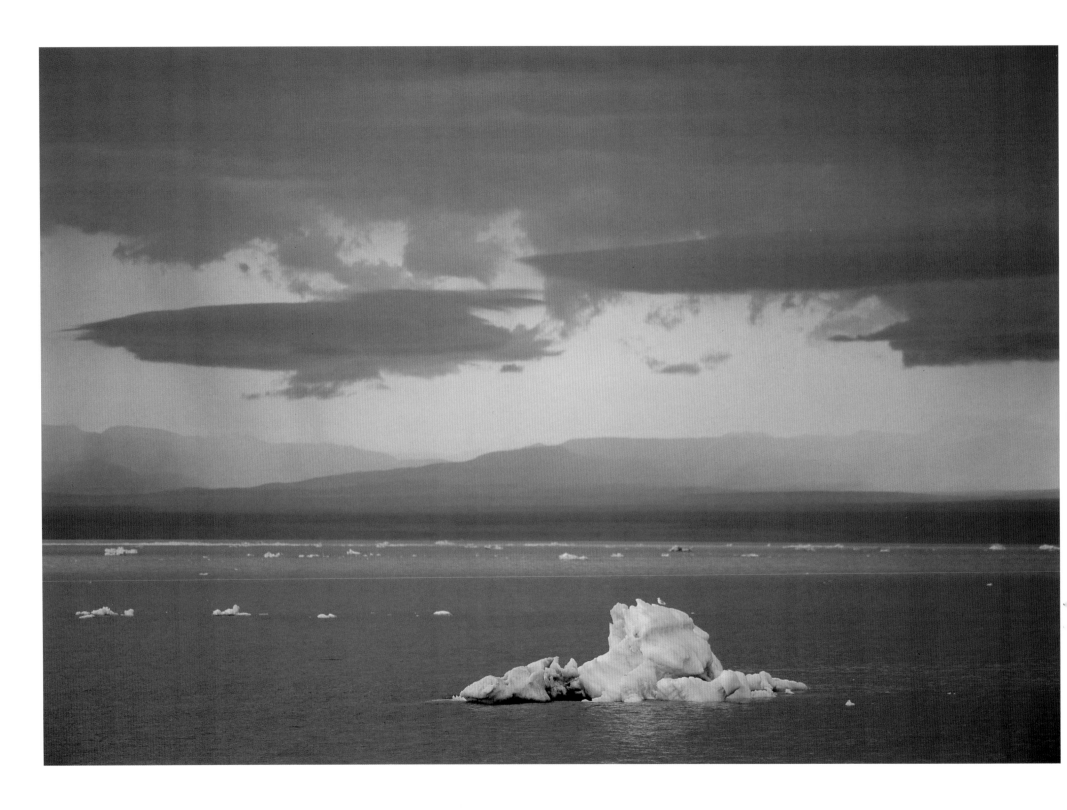

Sequence 1: *Summer thunderstorm over Alaska's Brooks Range meets the colder Arctic waters, and cylindrical, dark clouds begin to form a cold front.*

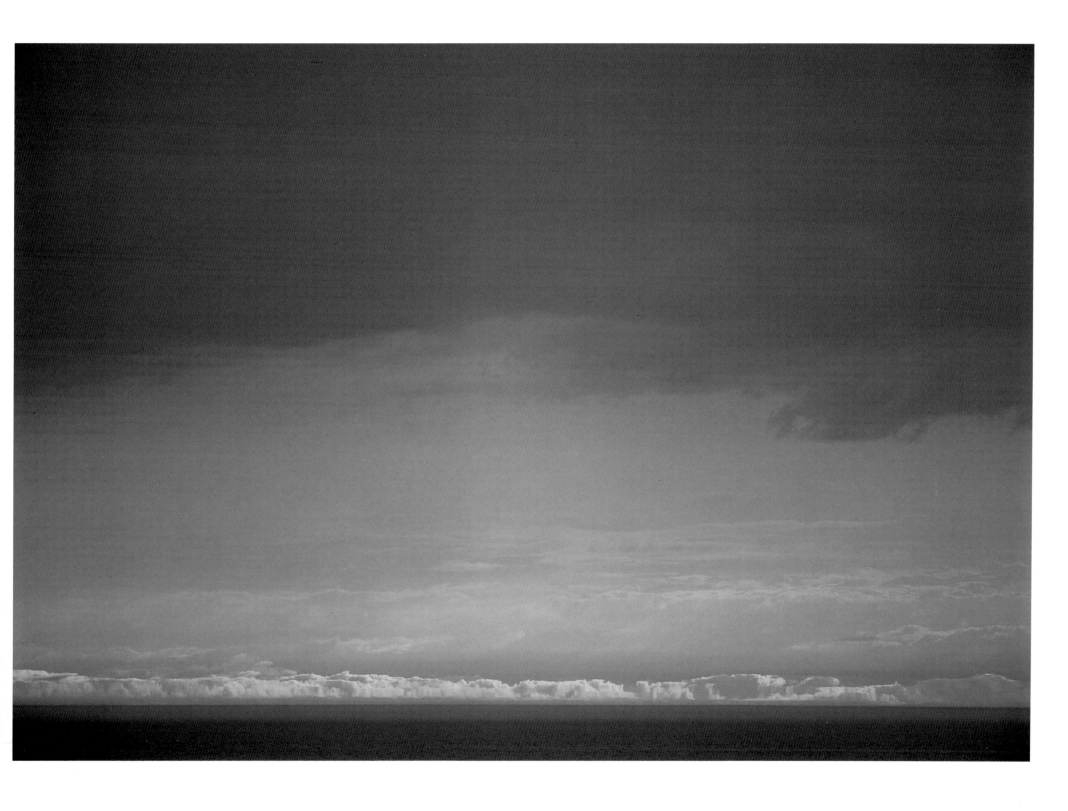

Sequence 2: *As the storm grows and the sky darkens, a mirage forms that appears to be clouds at the horizon, lit by the evening sun.*

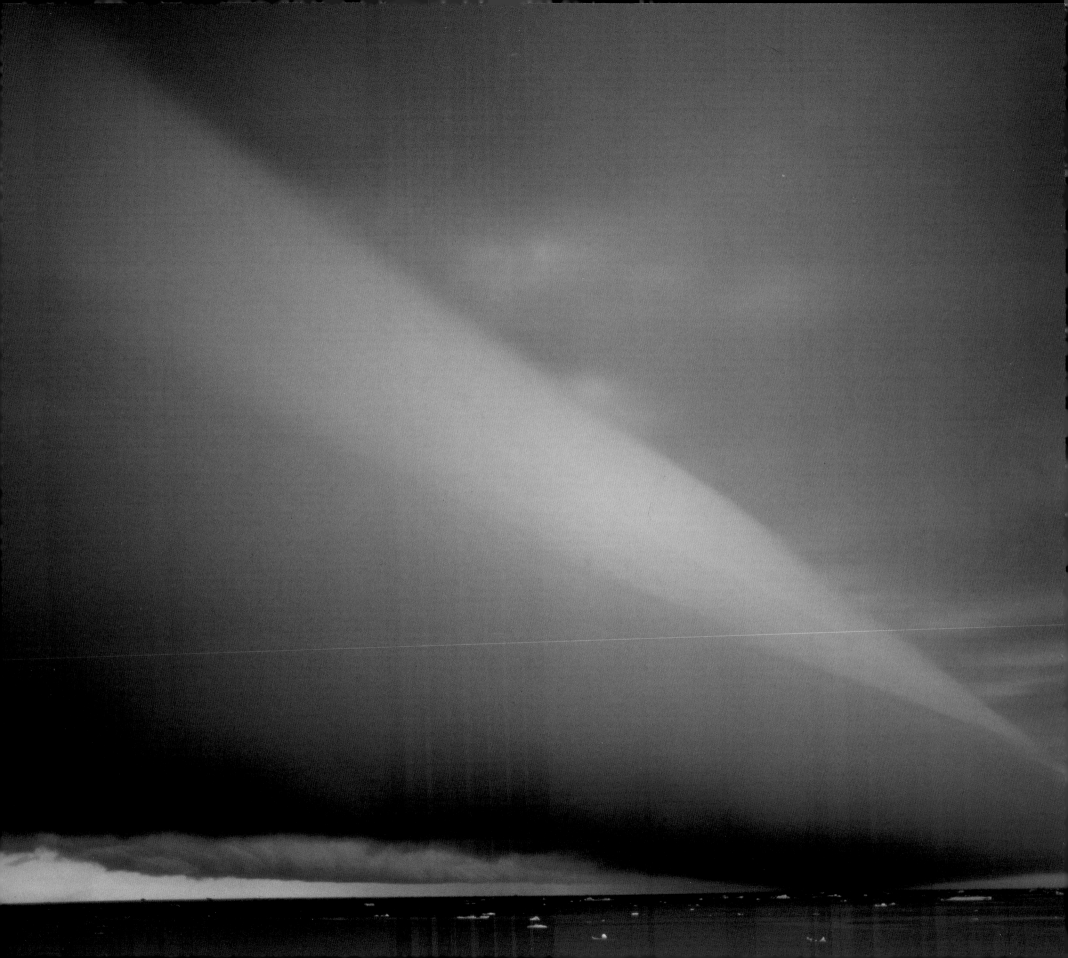

The beauty here is a beauty you feel in your flesh. You feel it physically, and that is why it is sometimes terrifying to approach. Other beauty takes only the heart, or the mind.

Sequence 3: *As warm air tumbles over cold air, the cylindrical clouds join, forming a massive cold front stretching from horizon to horizon.*

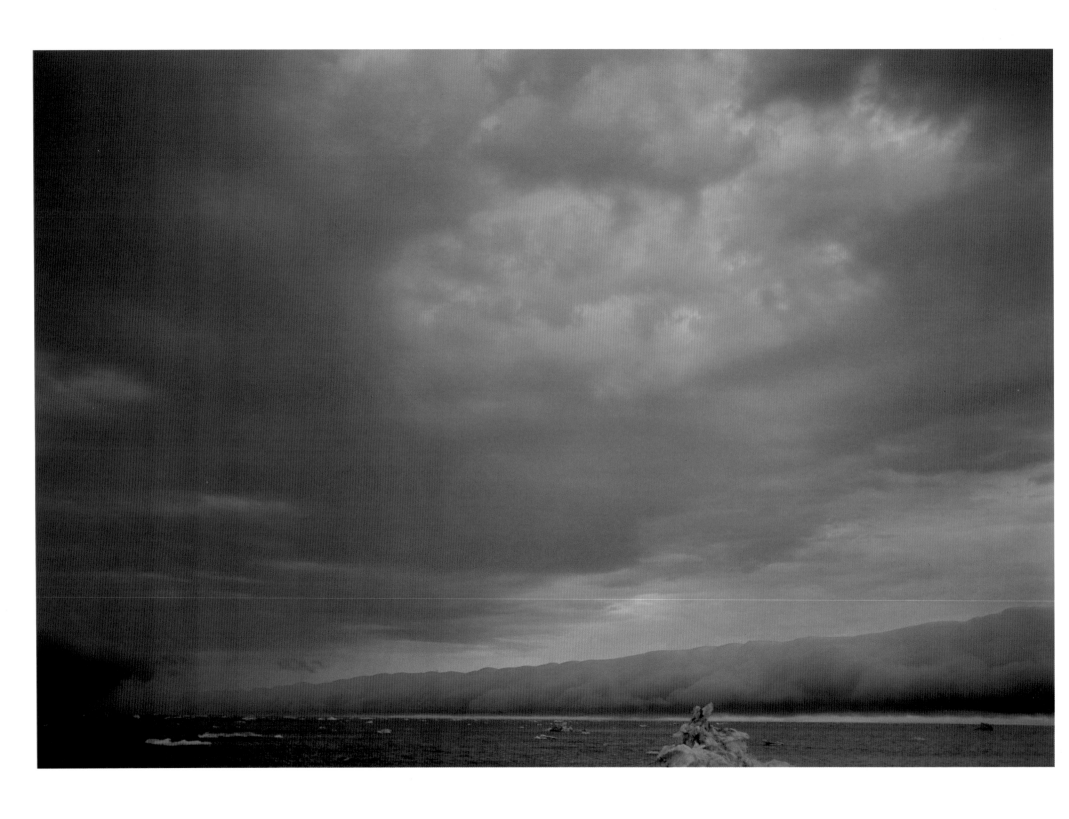

Sequence 4: *Traveling at thirty to forty miles per hour, the cold front rolls over the* Itasca *and continues off across the Beaufort Sea. In passing, it is accompanied by strong winds, rain, and hail, and the temperature drops fifteen degrees.*

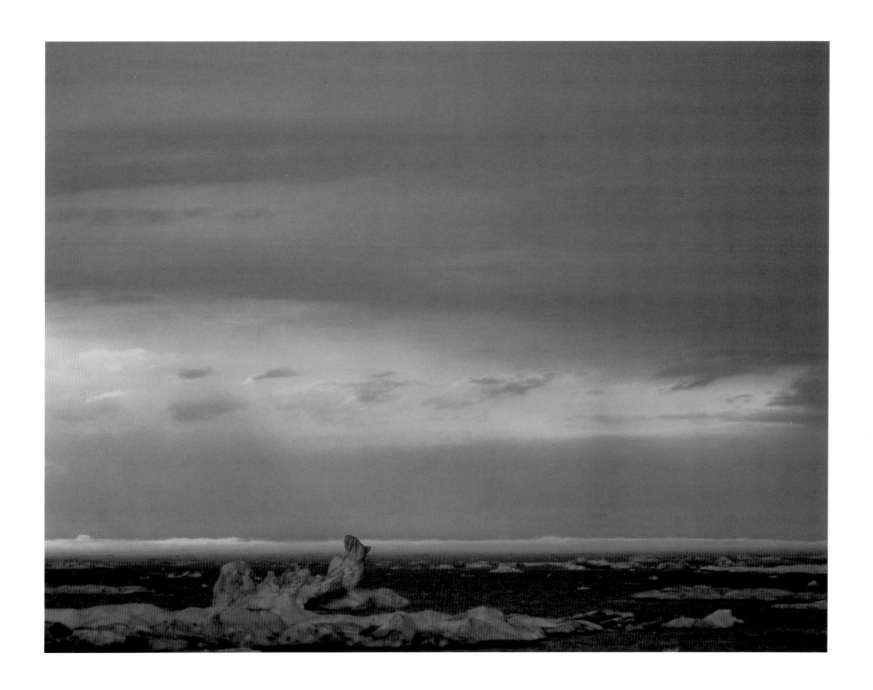

Sequence 5: *Immediately behind the storm, the sky begins to clear, illuminating sea ice still in the shadow of the weather, and causing it to radiate with an unusually intense blue glow.*

Icebergs create an unfamiliar sense of space because the horizon retreats from them and the sky rises without any lines of compression behind them. It is this perspective that frightened pioneer families on the treeless North American prairies. Too much space. . . .

Sequence 6: *Calm returns and the stormy skies light up in the setting sun.*

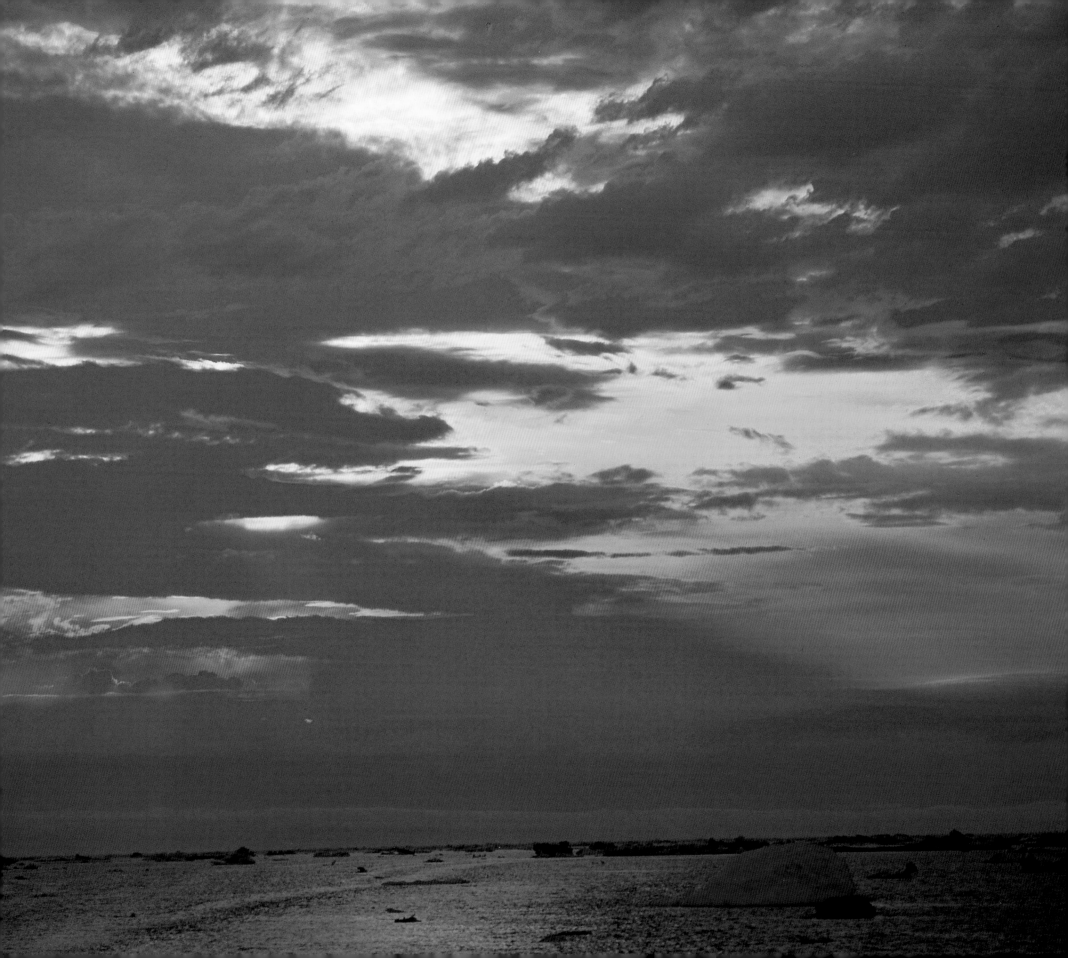

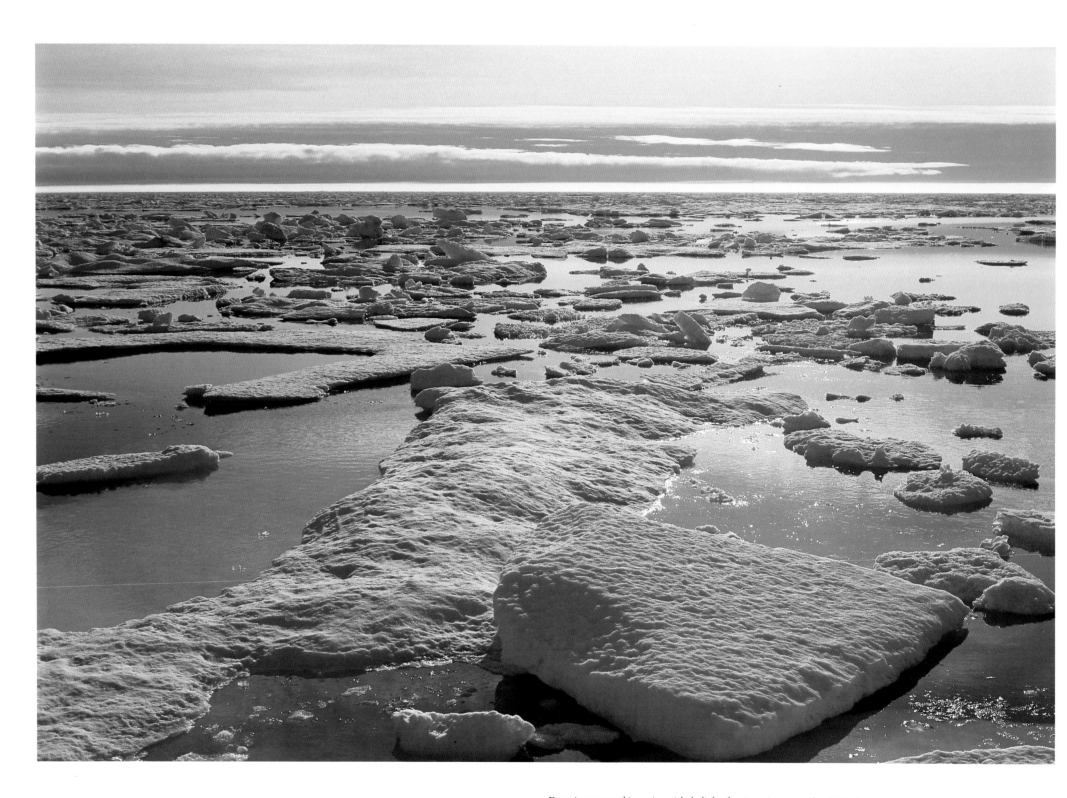

Dense ice coverage shimmering with the light of an incoming storm, Cape Victoria.

Fog-shrouded, horizonless ocean under a bright, overcast sky, Beaufort Sea.

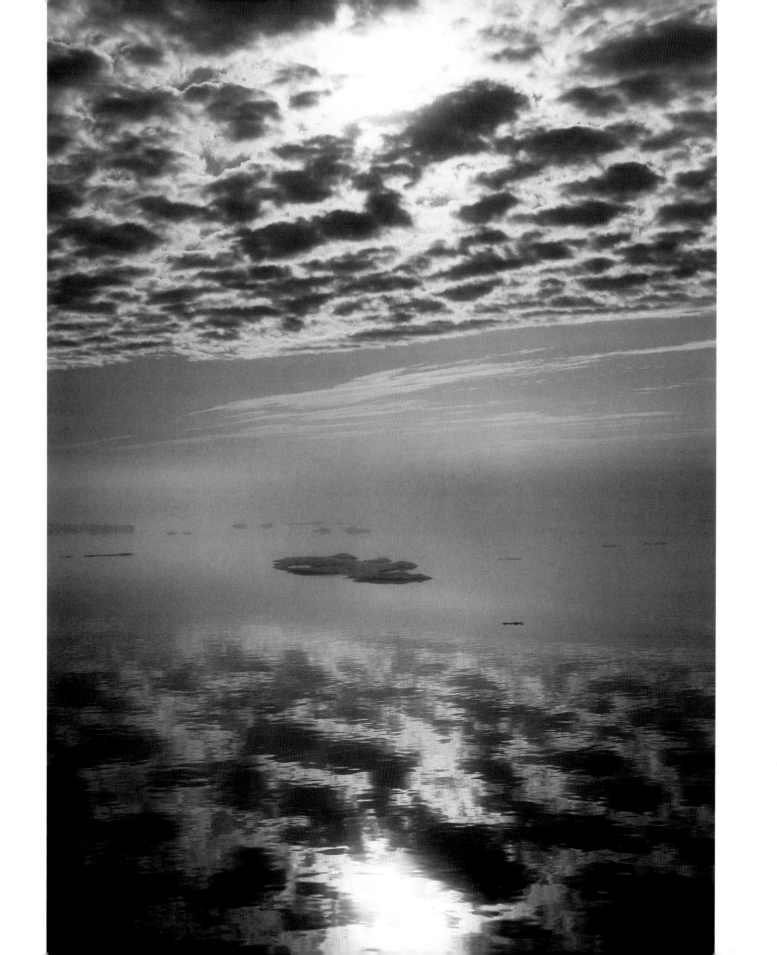

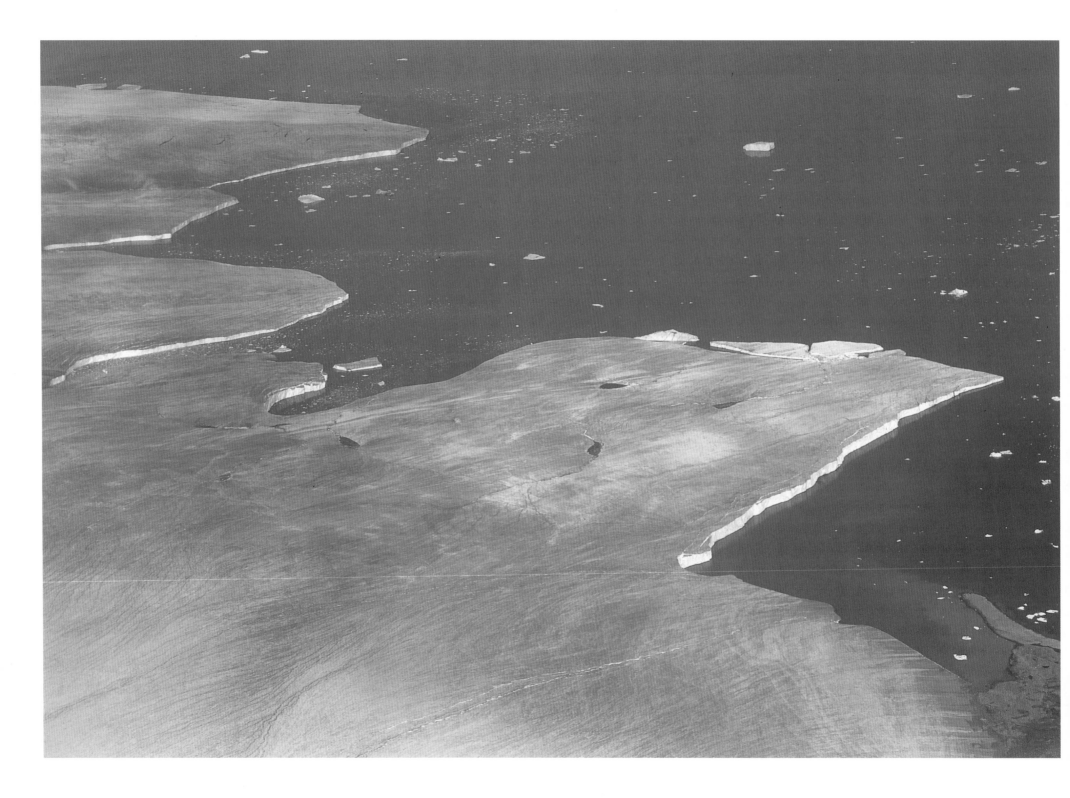

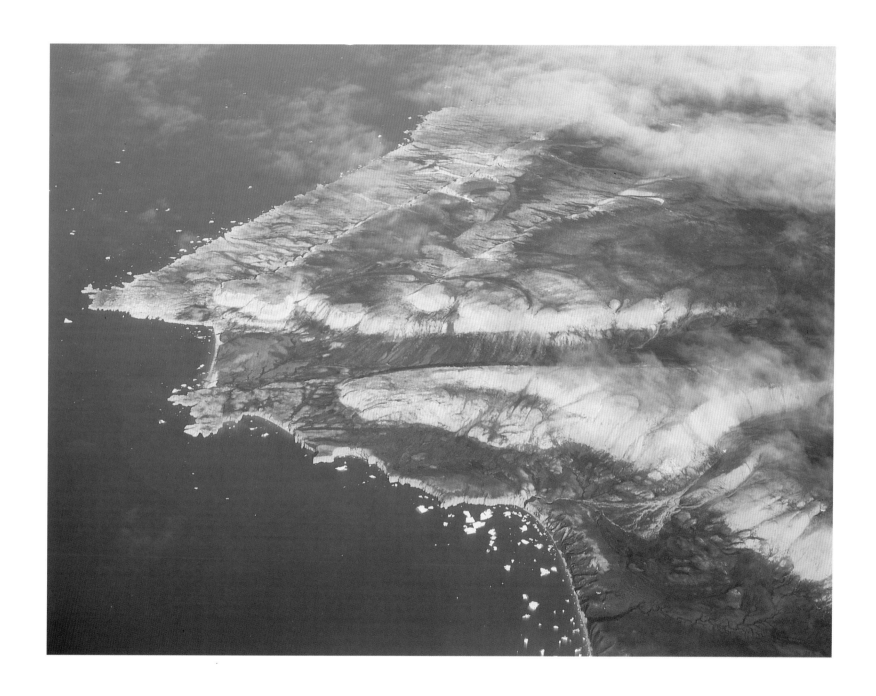

Rugged, mountainous peninsula and river valleys, Bylot Island.

A huge glacial "tongue" extending into the waters of Lancaster Sound and calving gigantic icebergs, Devon Island.

"Livin' under the big, big sky," Beaufort Sea.

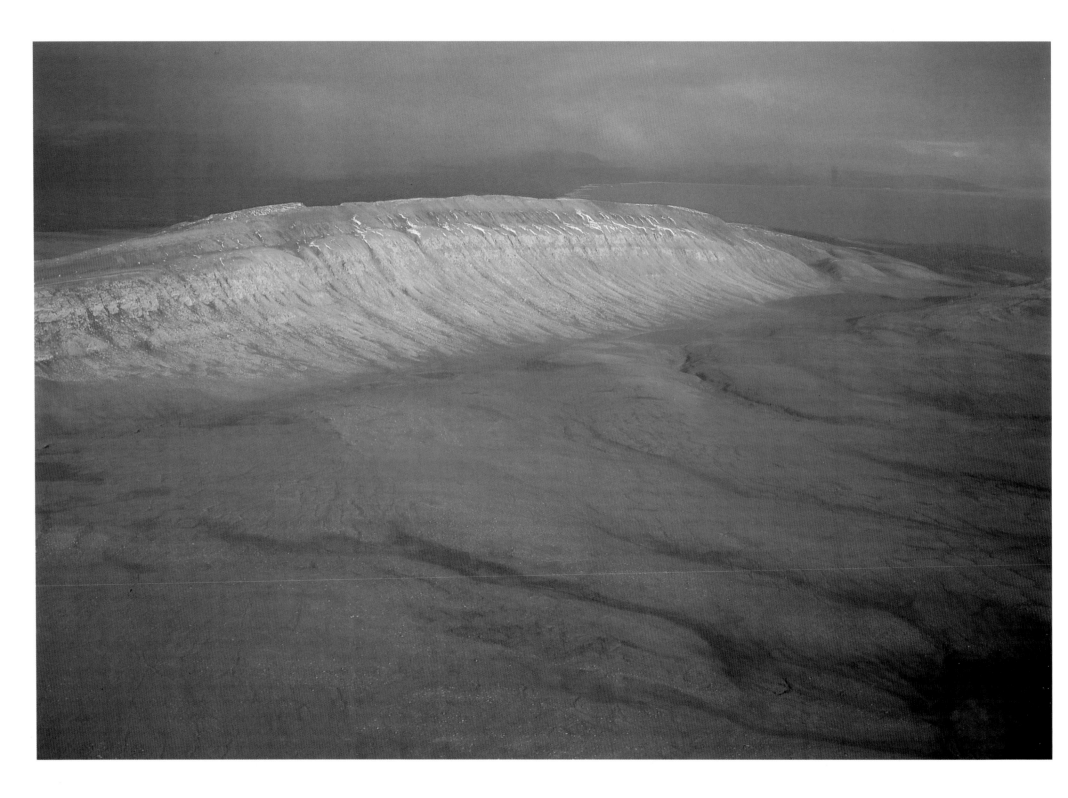

Late evening light as we approach Eureka weather station, Ellesmere Island.

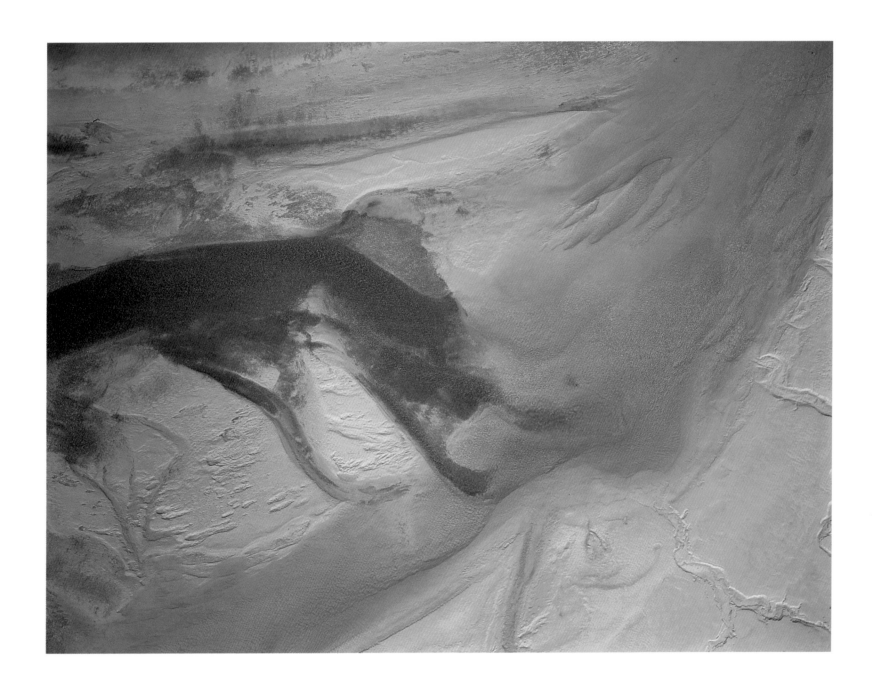

From directly overhead, meltwater in a stream appears turquoise blue as it flows over golden sand and silt bars, the Brodeur Peninsula of Baffin Island.

To inquire into the intricacies of a distant land-
scape…is to provoke thoughts about one's own
interior landscape, and the familiar landscapes of
memory. The land urges us to come around to an
understanding of ourselves.

… this affinity for the land, I believe, is an anti-
dote to the loneliness that in our own culture we
associate with individual estrangement and
despair.

The ragged shoreline mountains of Baffin Island in the passage from Pond Inlet to Baffin Bay.

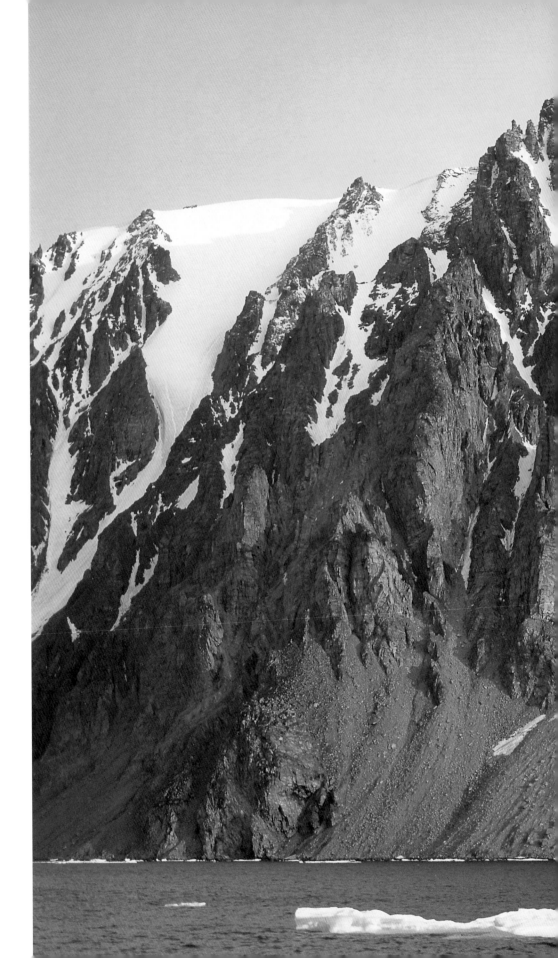

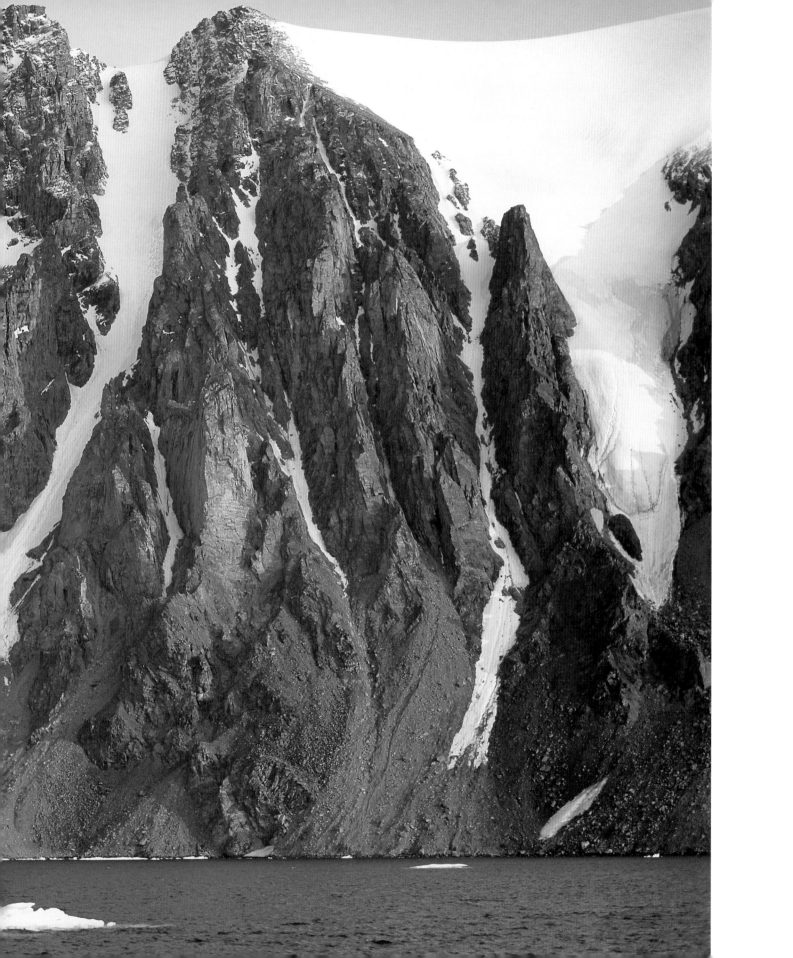

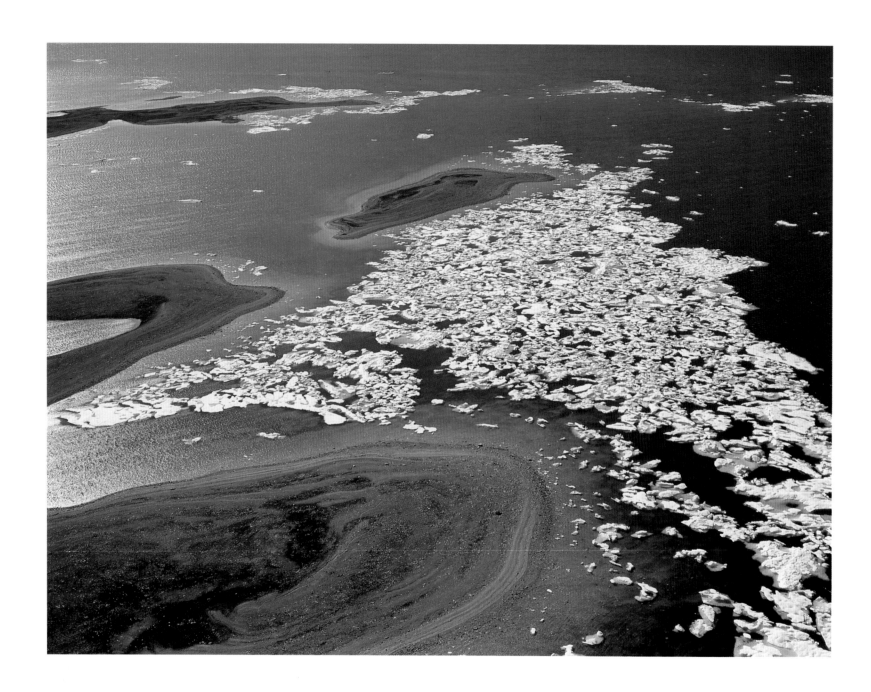

Sea ice collects around isostatic rebound islands just emerging from beneath the ocean.

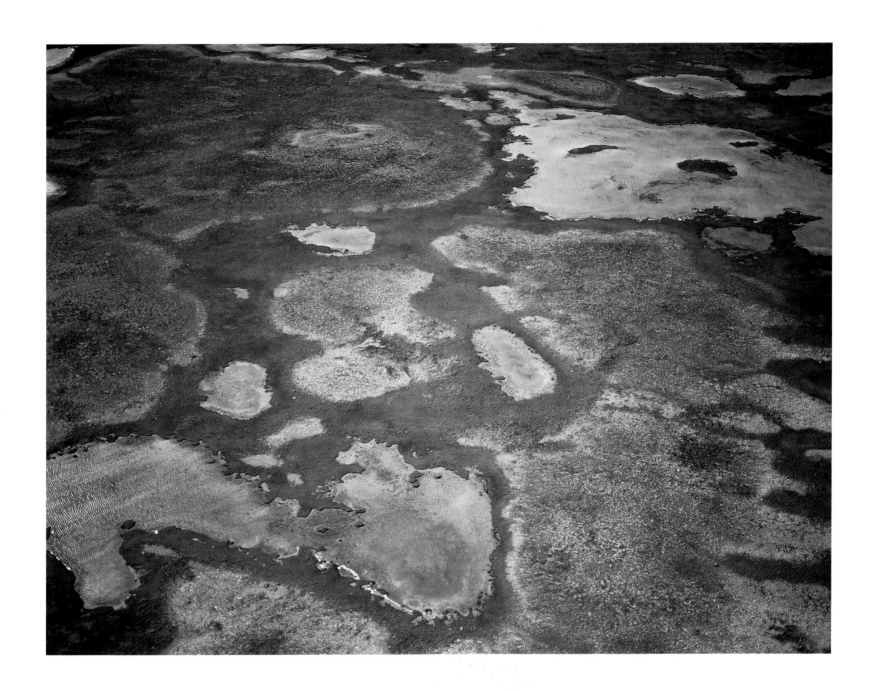

On the flat, frozen landscape of the rebound islands scattered between the Gibson Peninsula and Matty Island, rain and melted snow create thousands of shallow lakes, some green with algae growth.

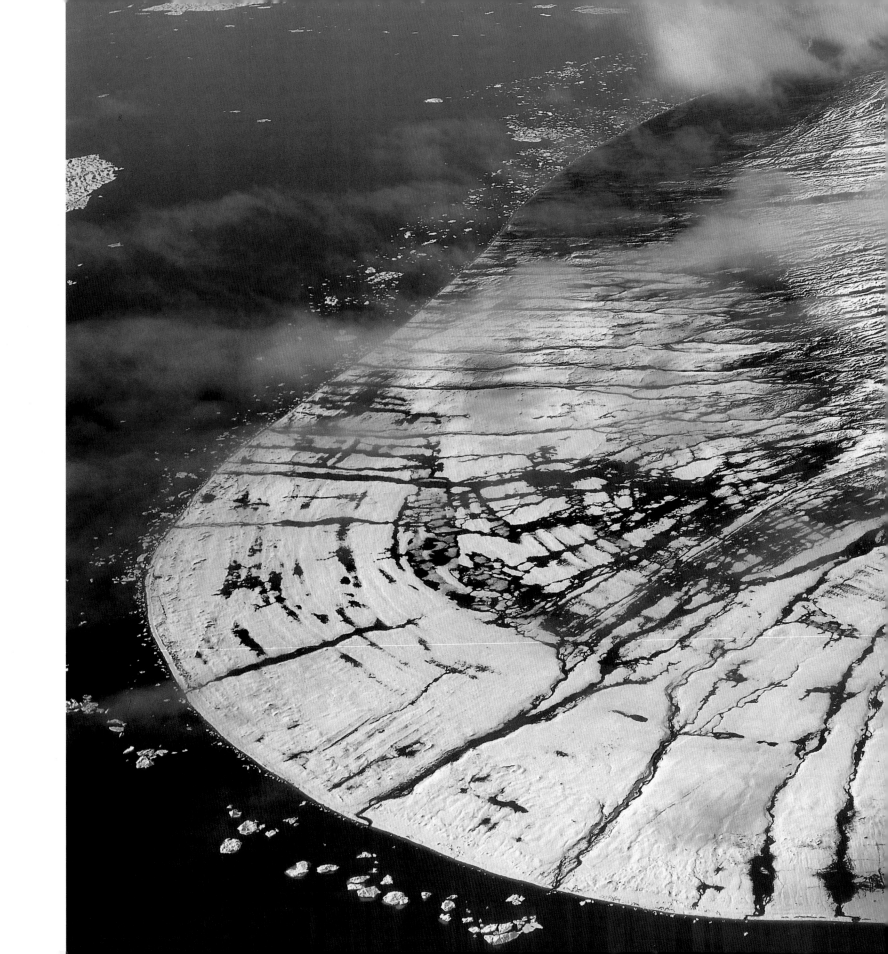

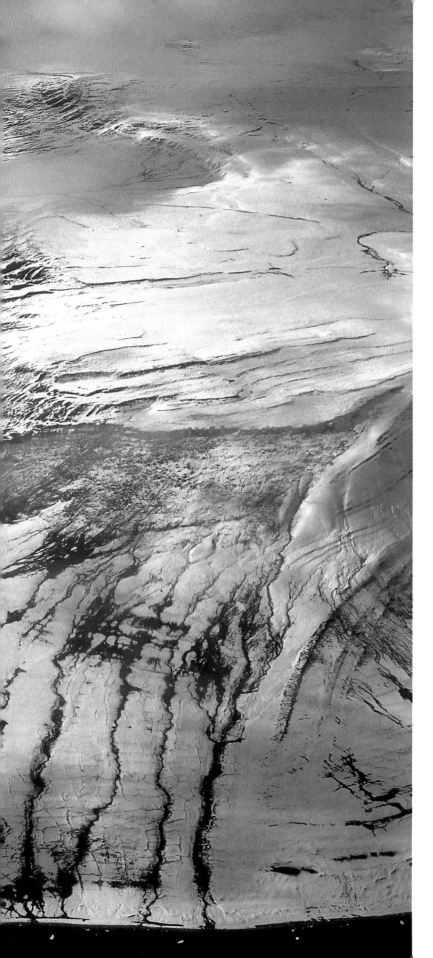

The physical landscape is baffling in its ability to transcend whatever we would make of it. It is as subtle in its expression as turns of the mind, and larger than our grasp; and yet it is still knowable. The mind, full of curiosity and analysis, disassembles a landscape and then reassembles the pieces—the nod of a flower, the color of the night sky, the murmur of an animal—trying to fathom its geography. At the same time the mind is trying to find its place within the land, to discover a way to dispel its own sense of estrangement.

A mountainous peninsula on Axel Heiberg Island covered by a late August snow.

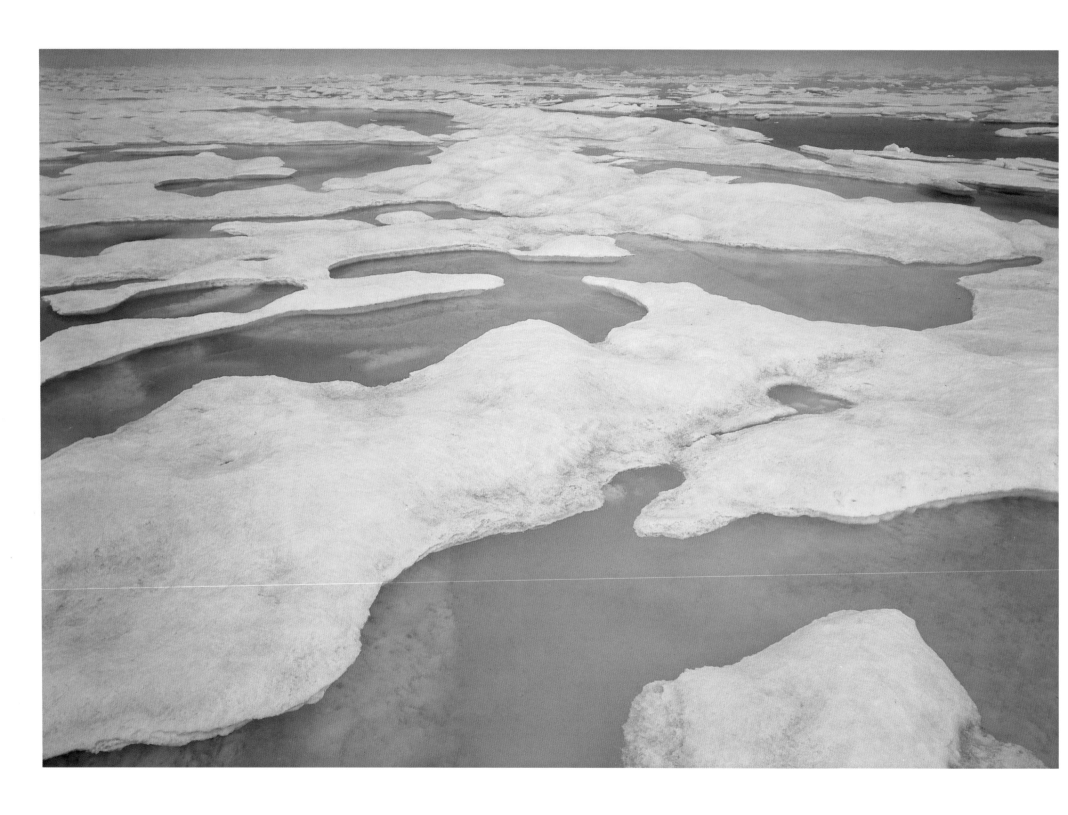

Pale-blue rainwater pools collect on the surface of sea ice.

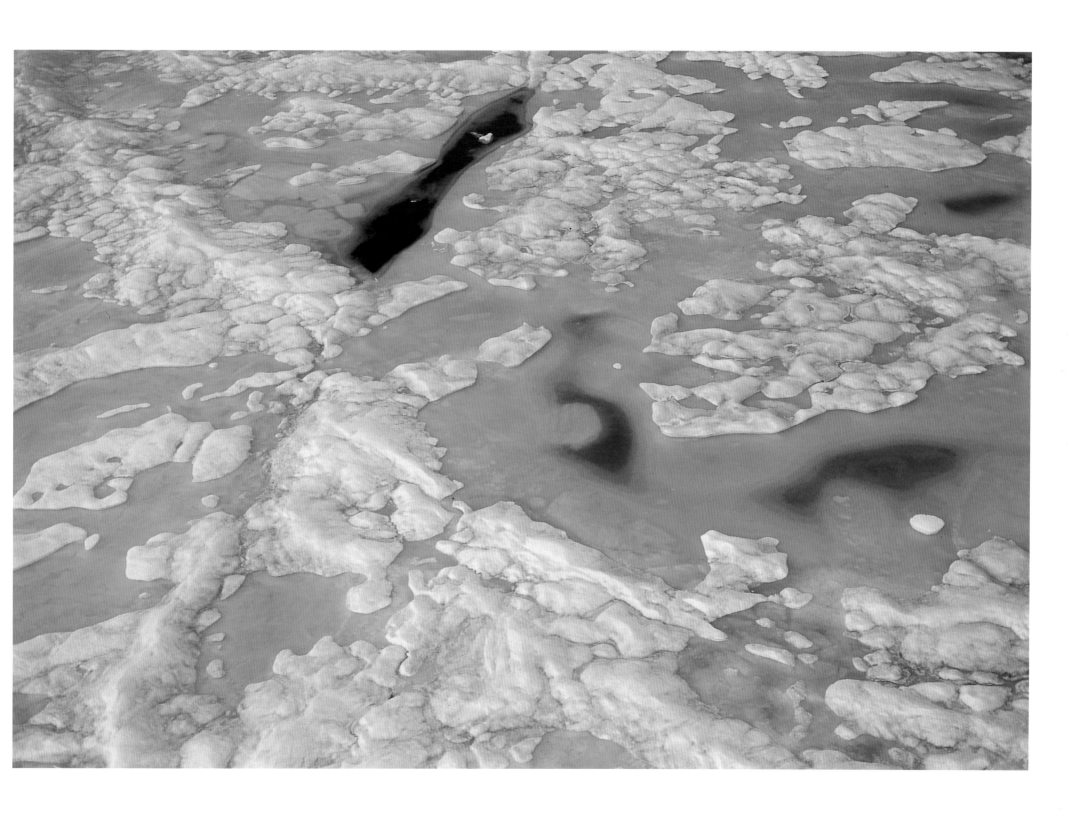

Dark-blue holes opening to the ocean contrast with paler rainwater pools on the surface of a massive floeberg.

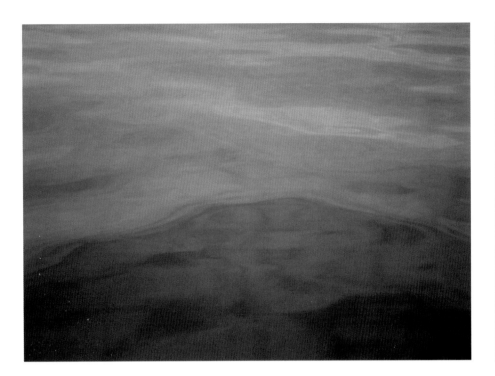 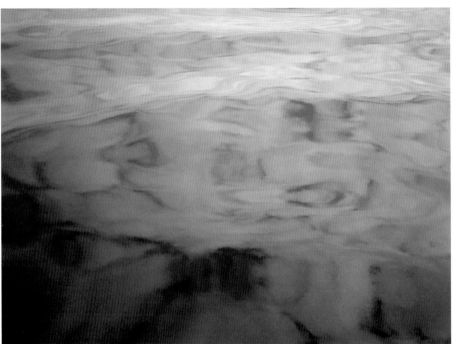

In glassy, dead-calm conditions created by good weather and the presence of ice (which supresses wave action), the ocean waters of the Arctic dance with abstract reflections.

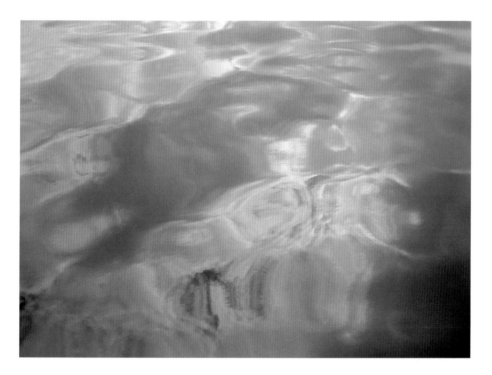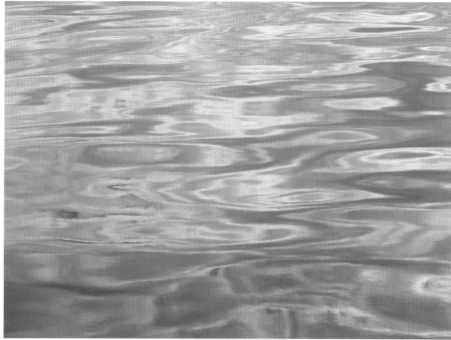

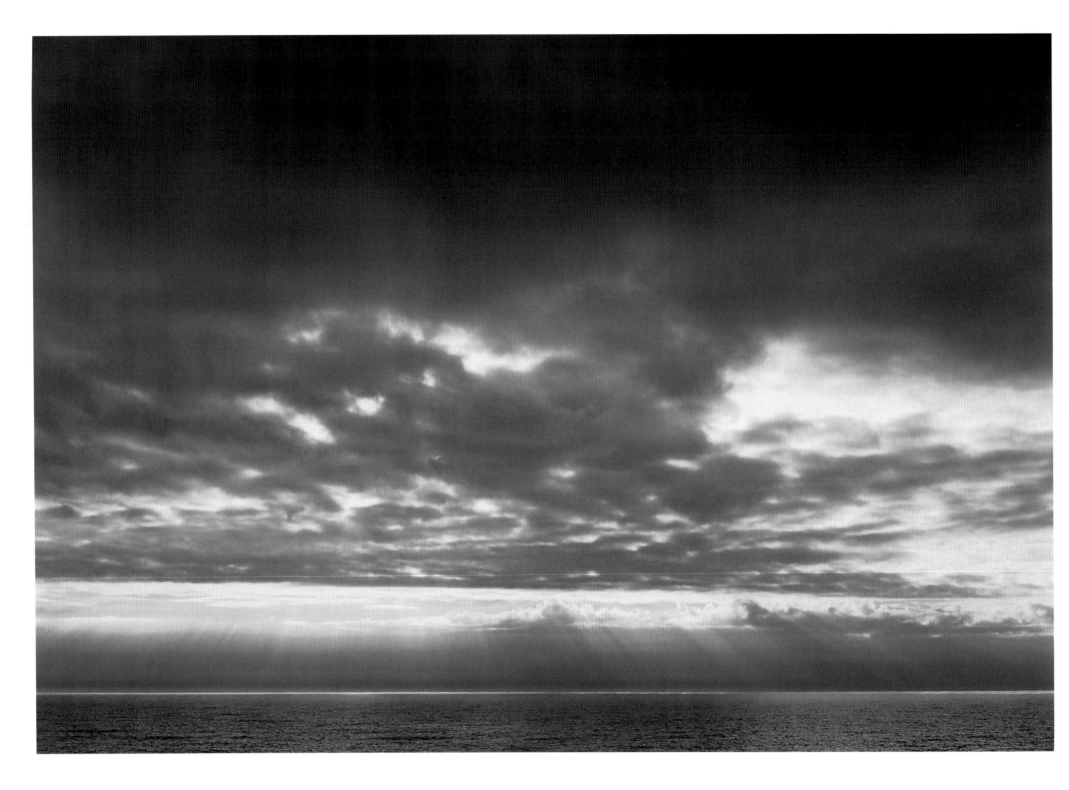

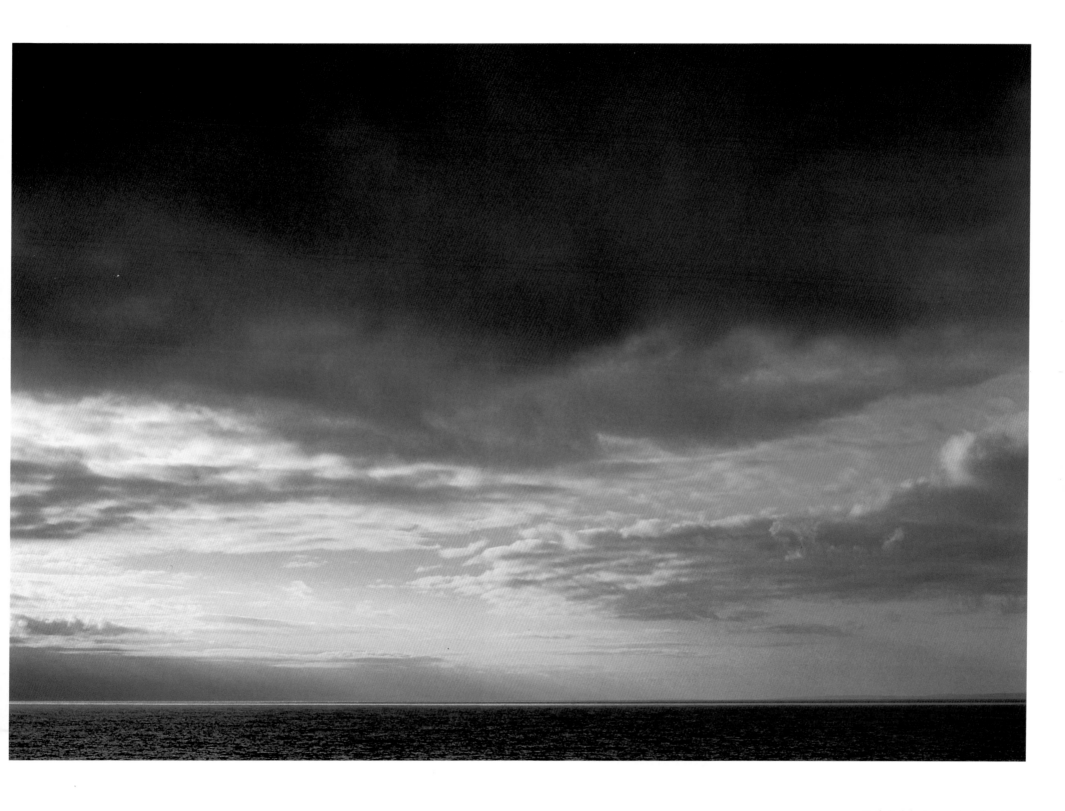

Cathedral sky, late evening, Chukchi Sea.

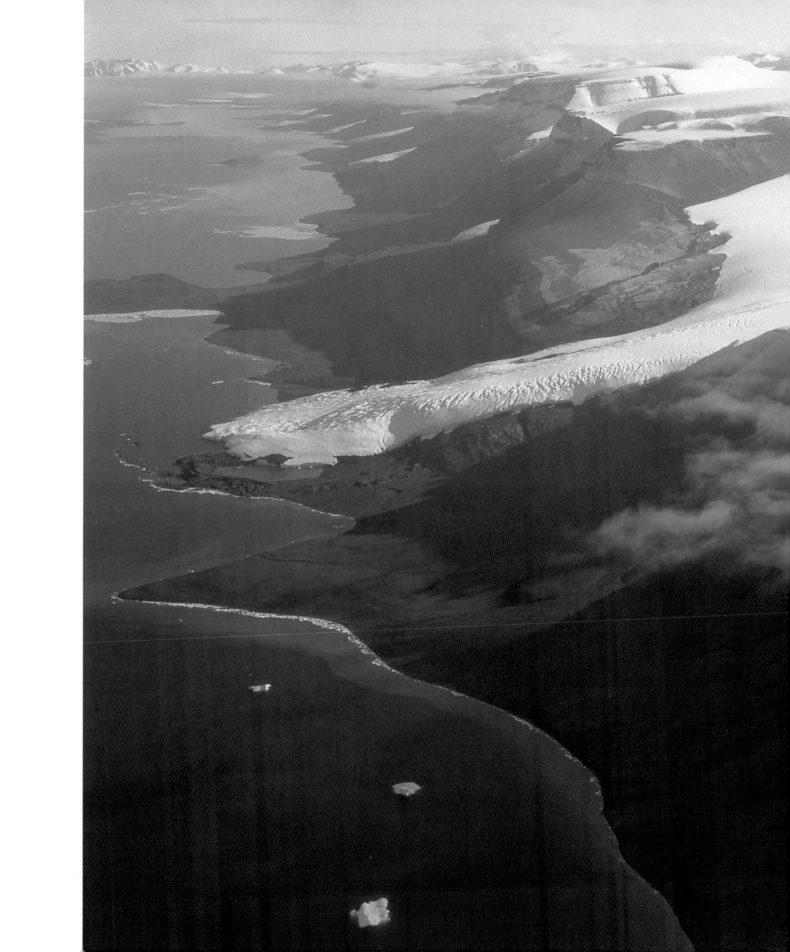

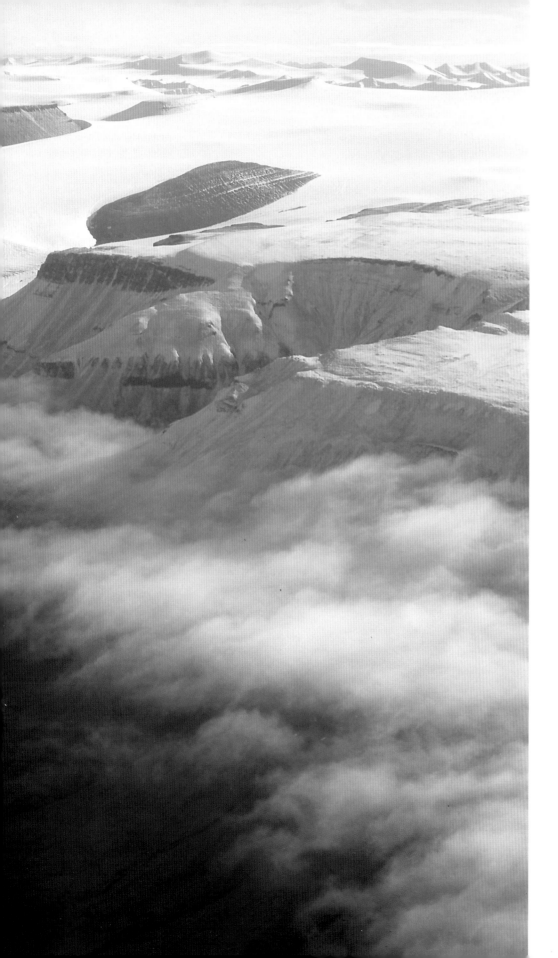

…Wild Ellesmere, with its Agassiz Ice Cap and exotic plateaus, a daydreamed landscape of my youth.

This is a land where airplanes track icebergs the size of Cleveland and polar bears fly down out of the stars. In a simple bow from the waist before the nest of a horned lark, you are able to stake your life, again, in what you dream.

Stretching to the horizon, a shoreline of Ellesmere Island is distinguished by alternating mountains and glaciers extending from the ice cap to tidewater.

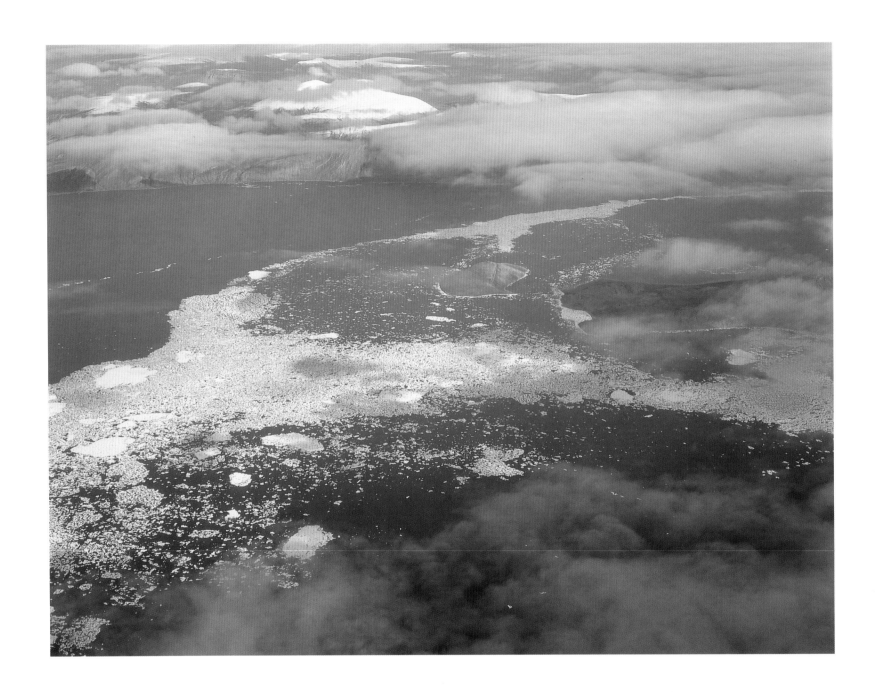

Ice floes and small islands offshore of Ellesmere.

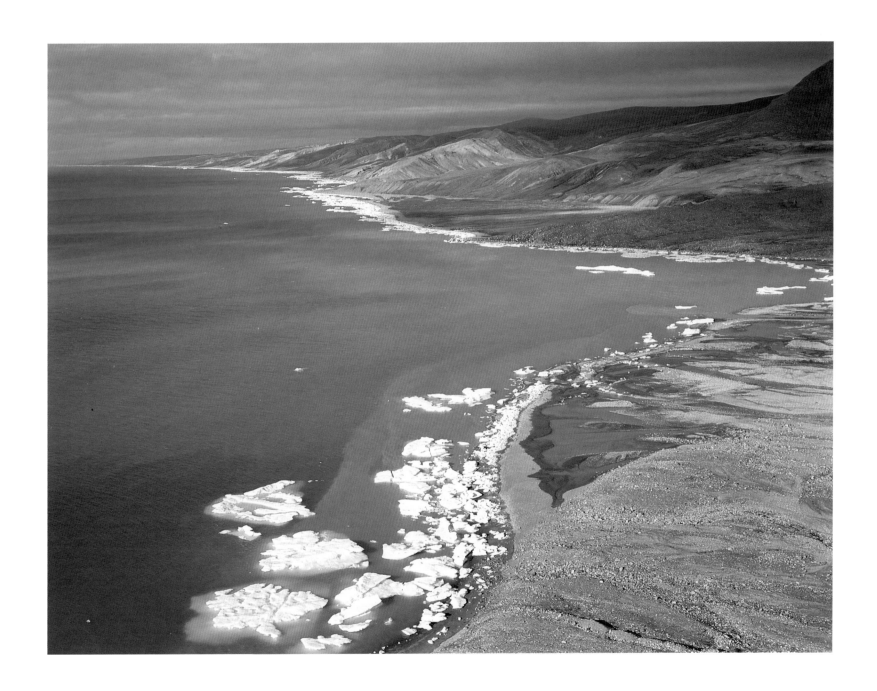

Icebergs and sea ice along the shoreline of Bylot Island.

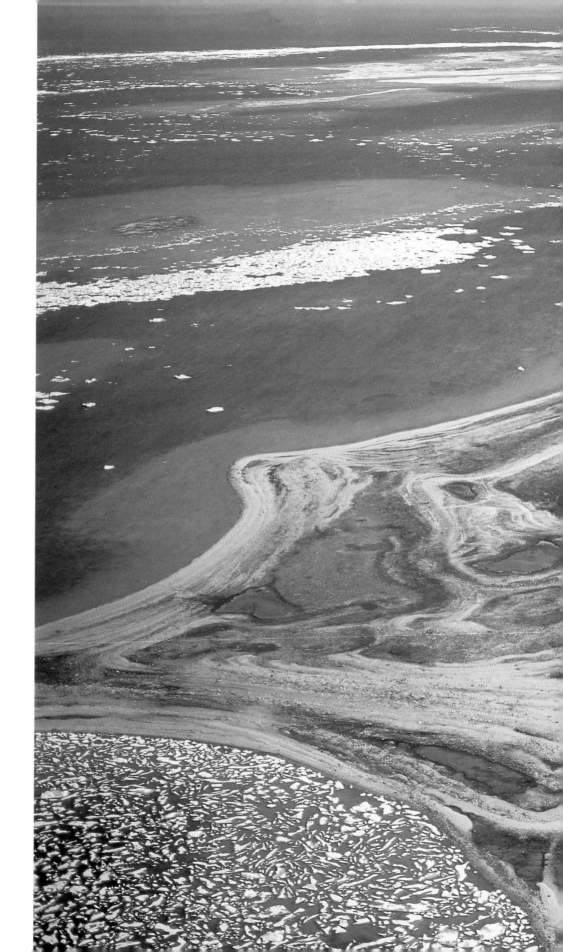

Whatever evaluation we finally make of a stretch of land . . . no matter how profound or accurate, we will find it inadequate. The land retains an identity of its own, still deeper and more subtle than we can know. Our obligation toward it then becomes simple: to approach with an uncalculating mind, with an attitude of regard. To try to sense the range and variety of its expression—its weather and colors and animals. To intend from the beginning to preserve some of the mystery within it as a kind of wisdom to be experienced, not questioned. And to be alert for its openings, for that moment when something sacred reveals itself within the mundane, and you know the land knows you are there.

Ice crowds the shoreline of a frost-cracked rebound island studded with small lakes, James Ross Strait.

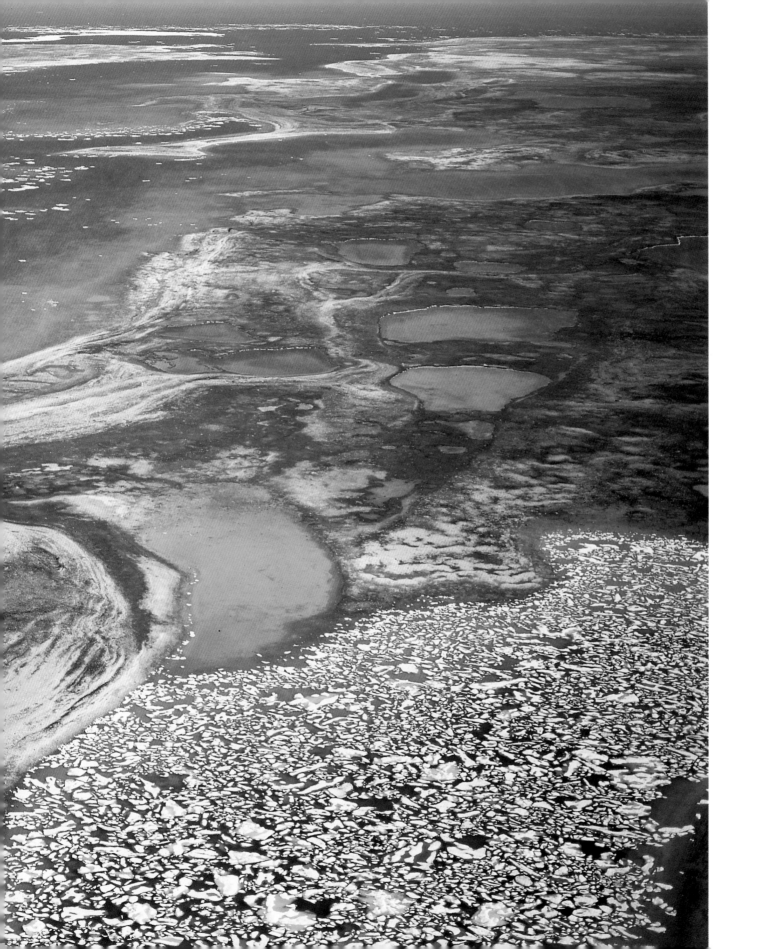

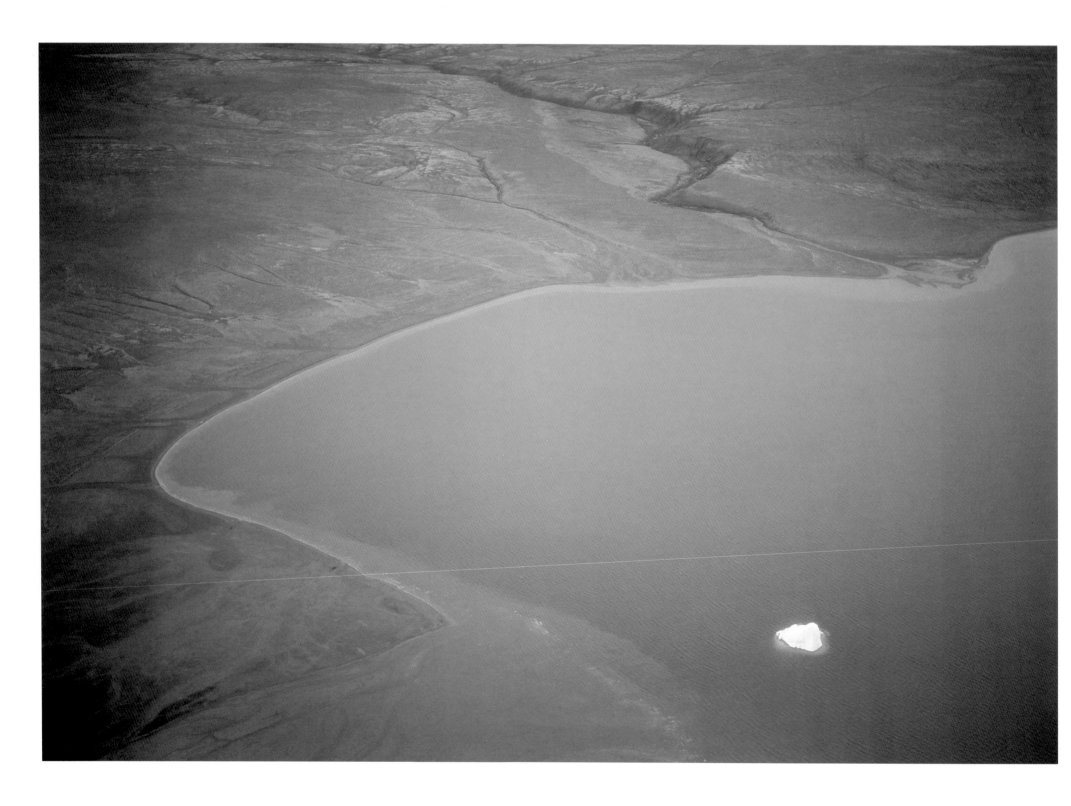

Solitary iceberg drifting in a bay of open water, Ellesmere Island.

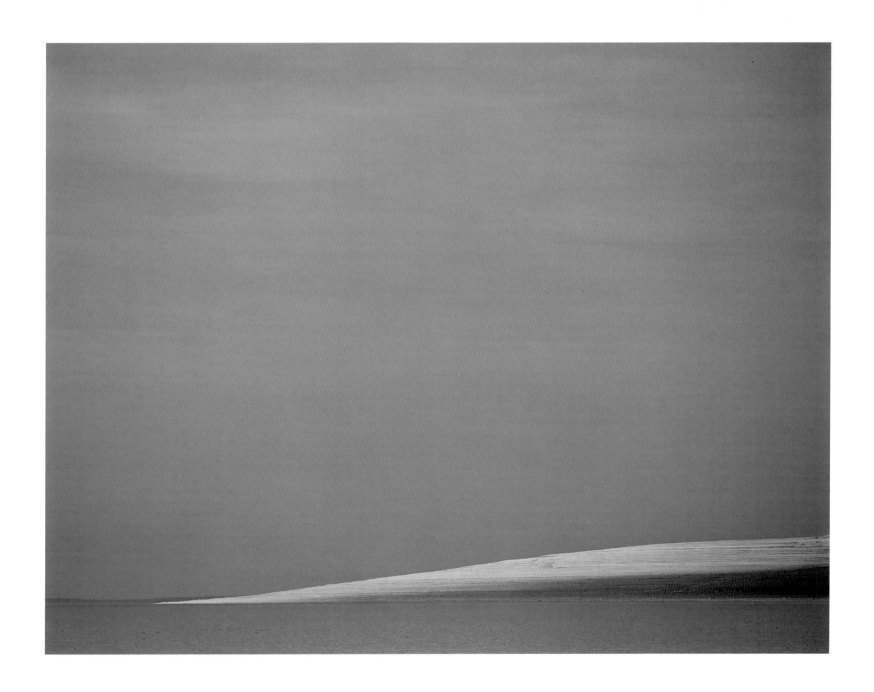

In a phenomenon known as "isostatic rebound," many islands are gradually rising from beneath the ocean, no longer repressed by the great weight of the retreating polar ice cap. Commonly called "rebound islands," they often have a striated appearance, because as they rise, successive years of sea ice build small ridges along their shorelines.

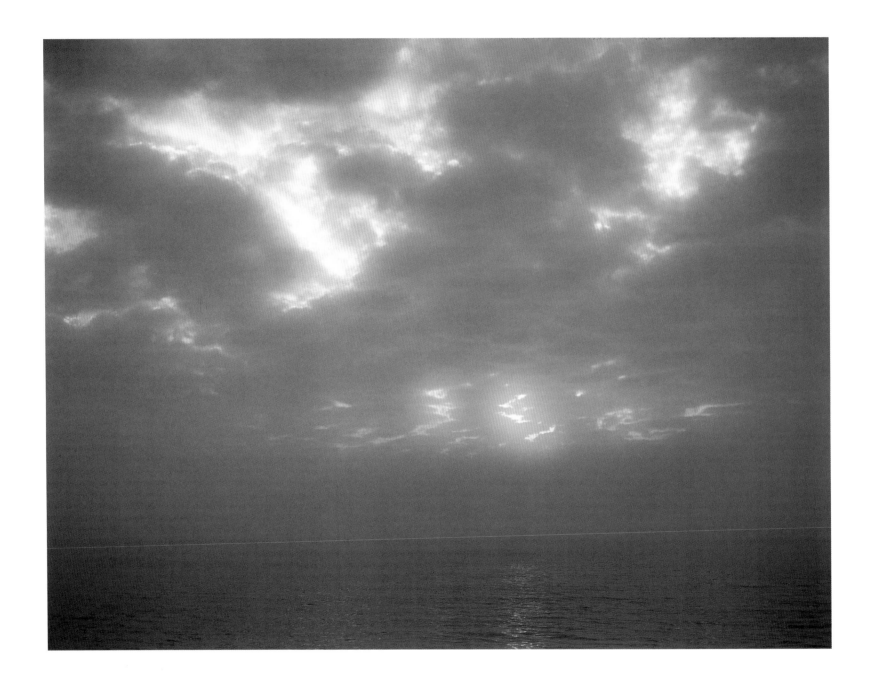

All is one.

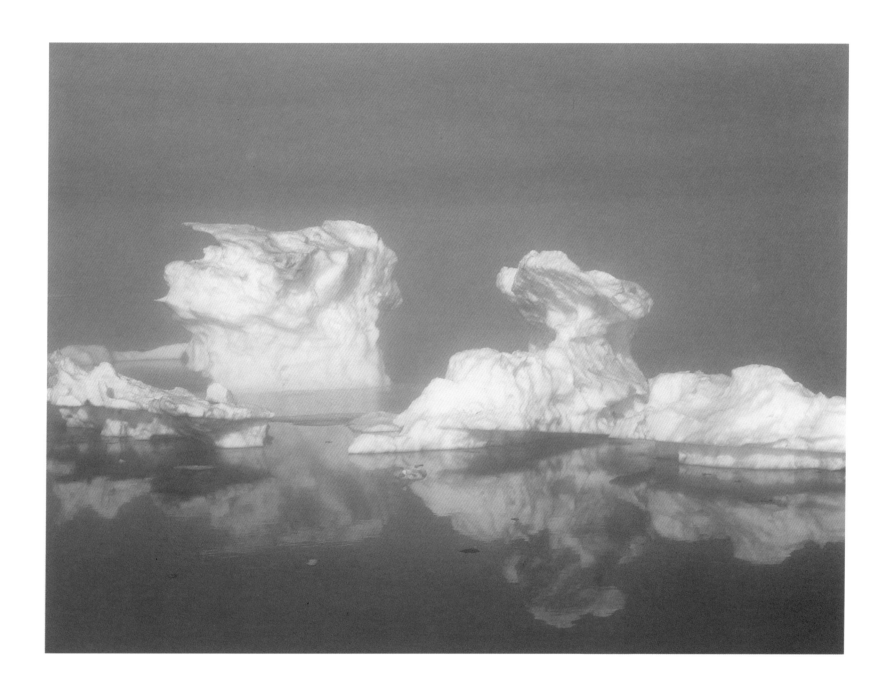

Sea ice gleaming through a light, morning haze.

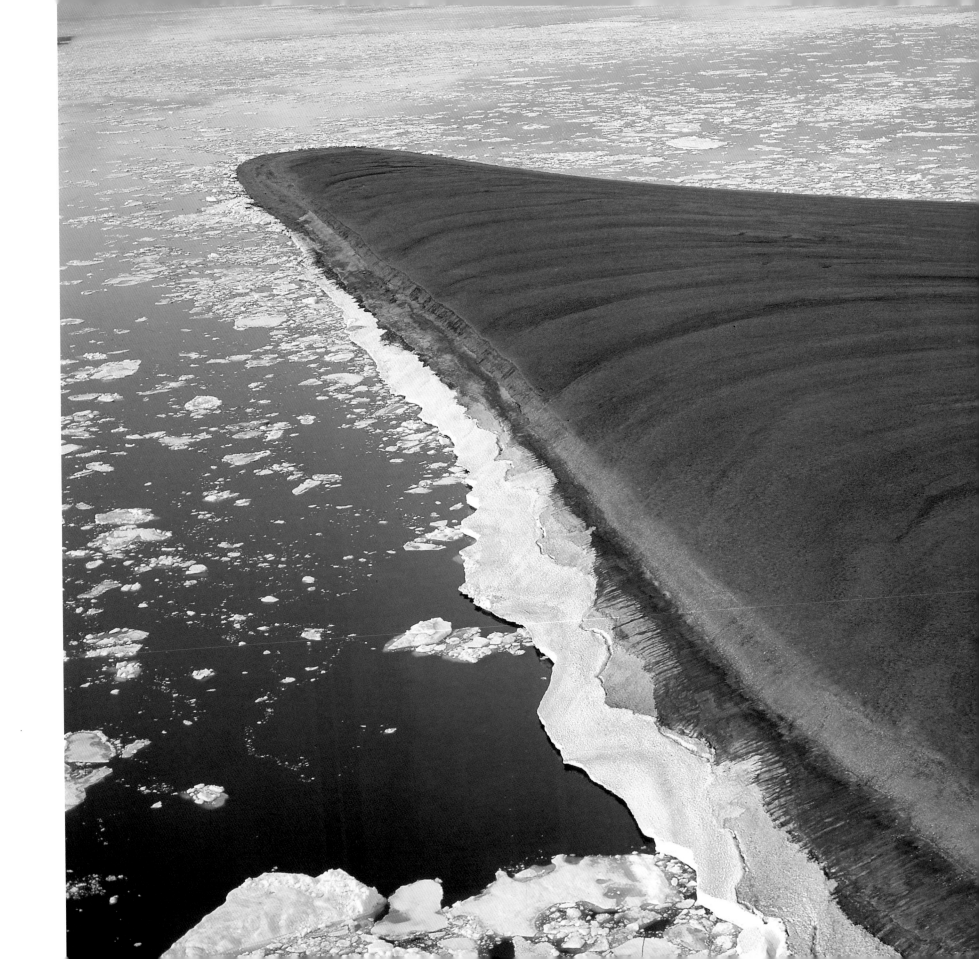

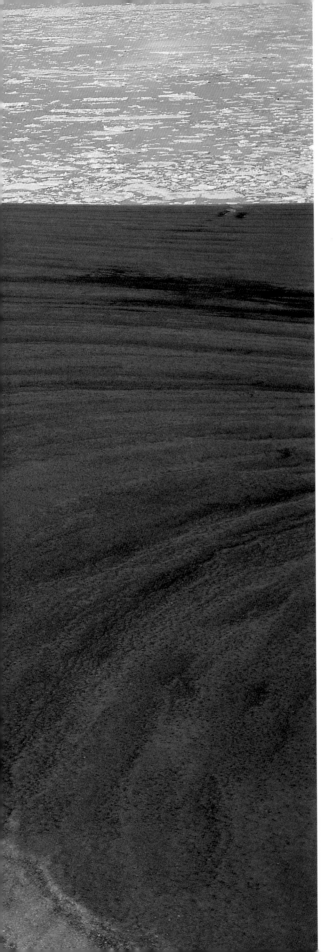

{To the explorer,} the land becomes large, alive like an animal; it humbles him in a way he cannot pronounce. It is not that the land is simply beautiful but that it is powerful. Its power derives from the tension between its obvious beauty and its capacity to take life. Its power flows into the mind from a realization of how darkness and light are bound together within it, and the feeling that this is the floor of creation.

A peninsula on Prince Leopold Island whose ice-fast shoreline has a pink hue, discolored by algae growth and deposits of blowing soil.

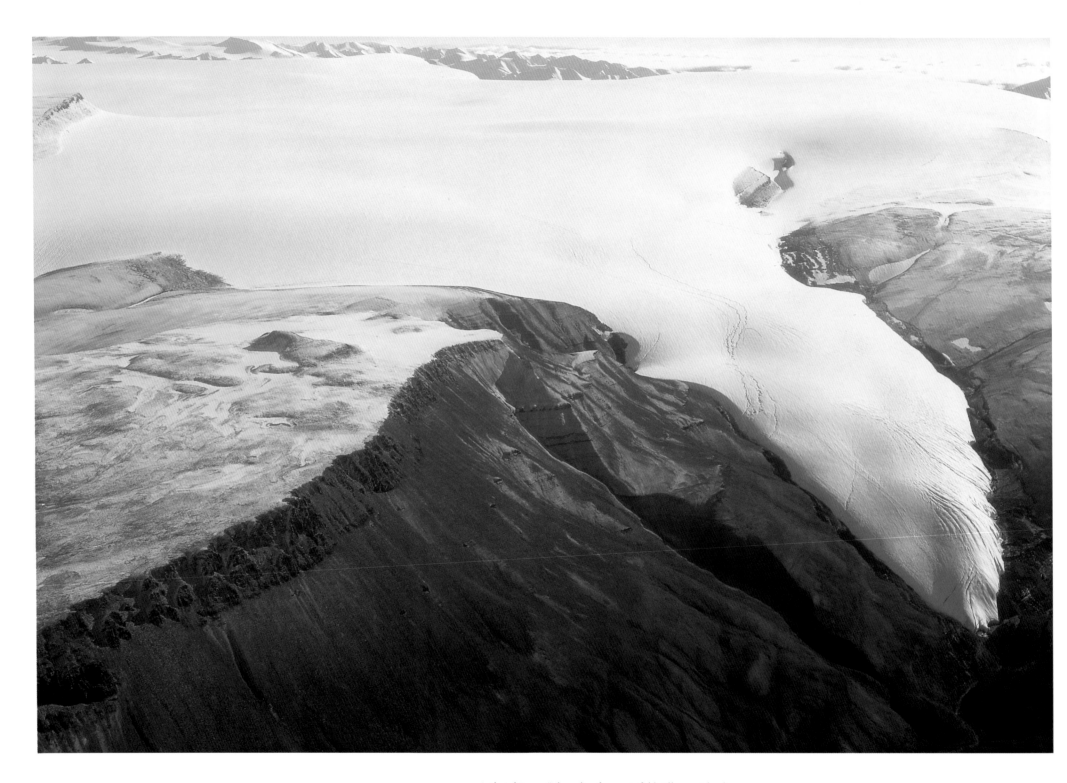

A glacial "tongue" descending from an icefield, Ellesmere Island.

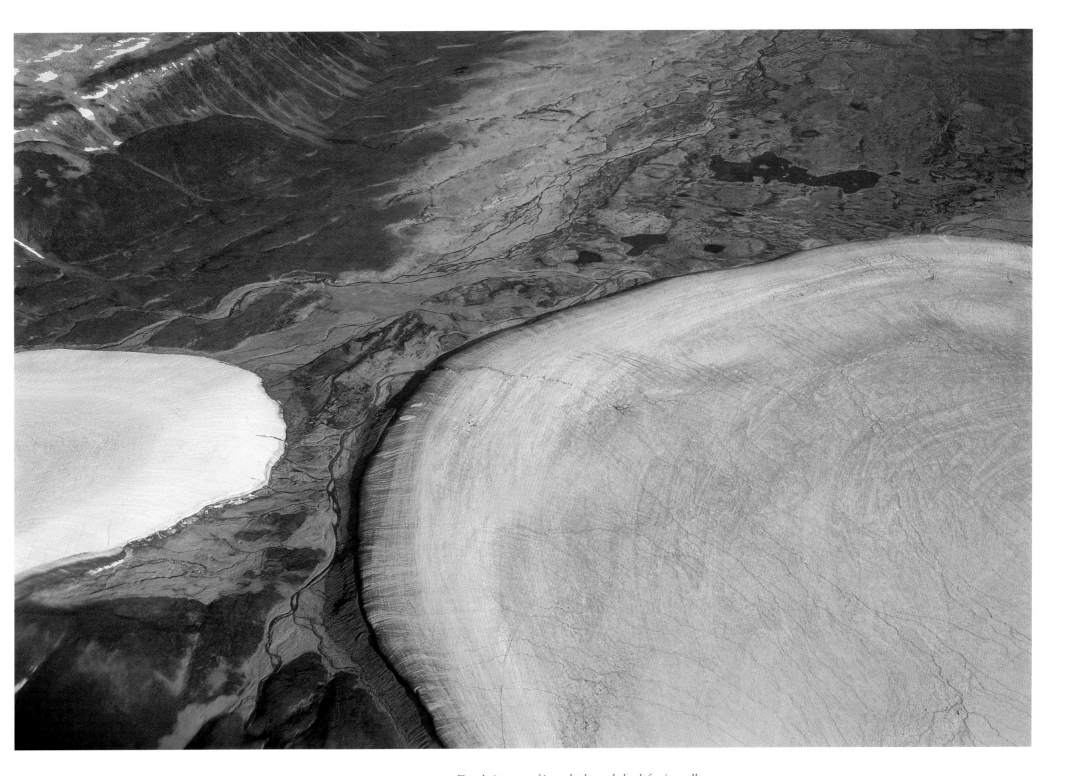

Two glaciers approaching each other at the head of a river valley.

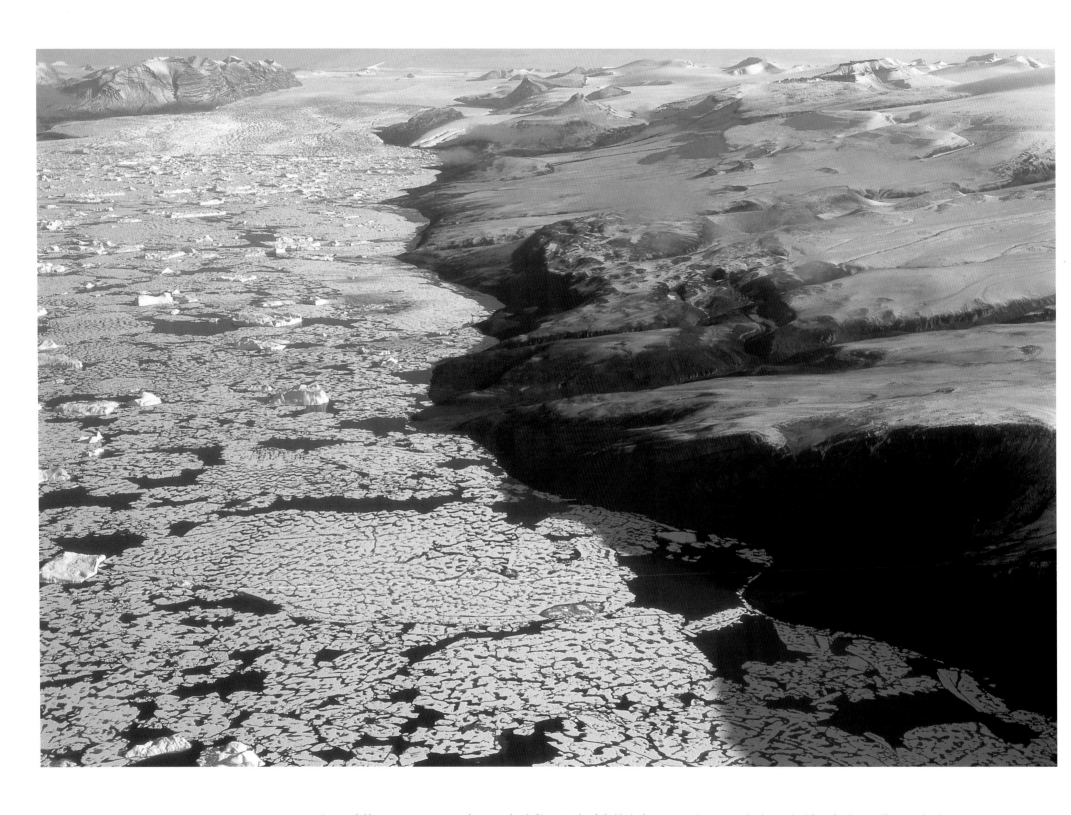

Surrounded by numerous mountains, the terminal end of Otto Fjord is choked by broken sea ice and monumental icebergs calved from the glacier, Ellesmere Island.

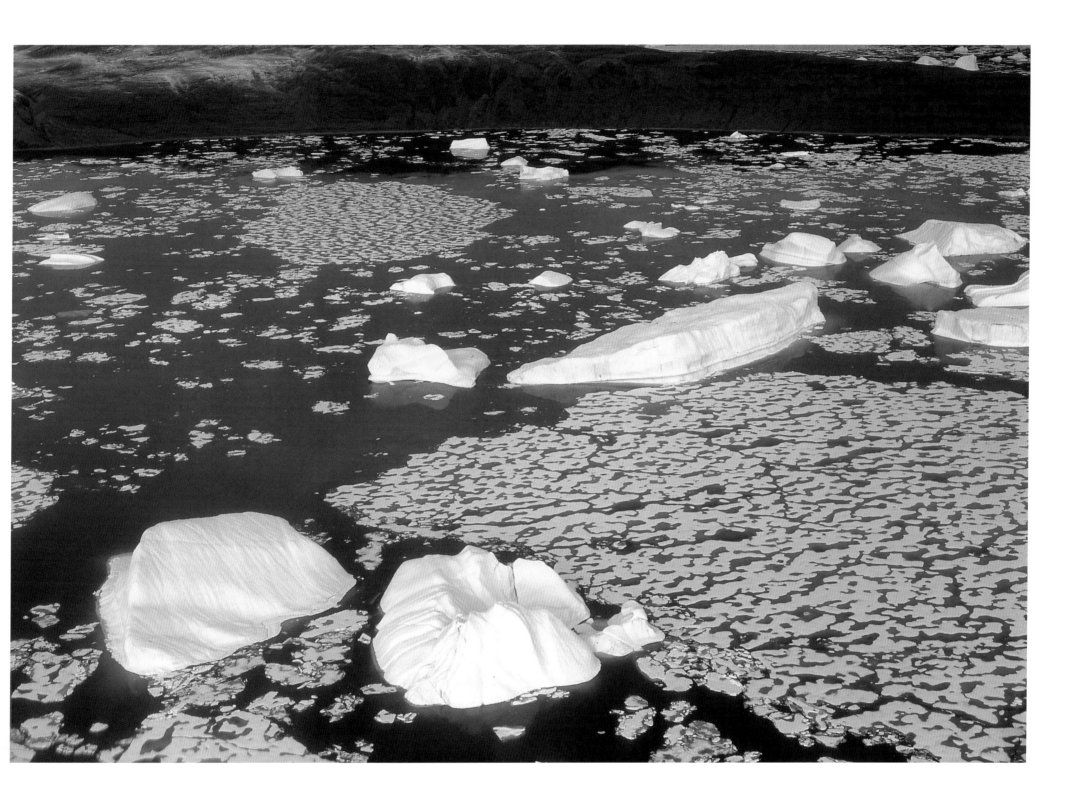

Icebergs drifting amongst the floes in Otto Fjord.

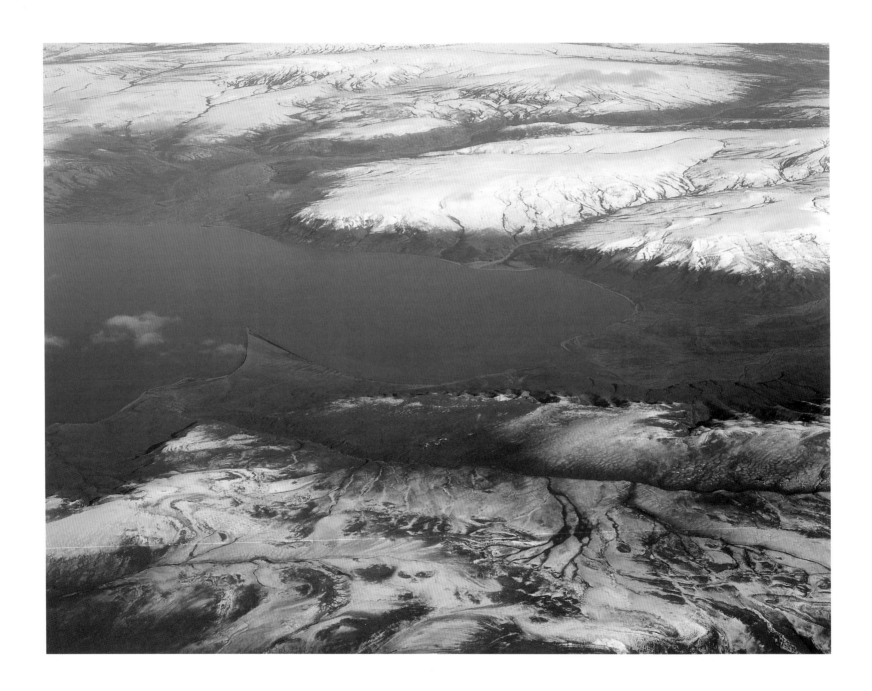

Snow-covered mountains, valleys, and a large bay, Ellesmere Island.

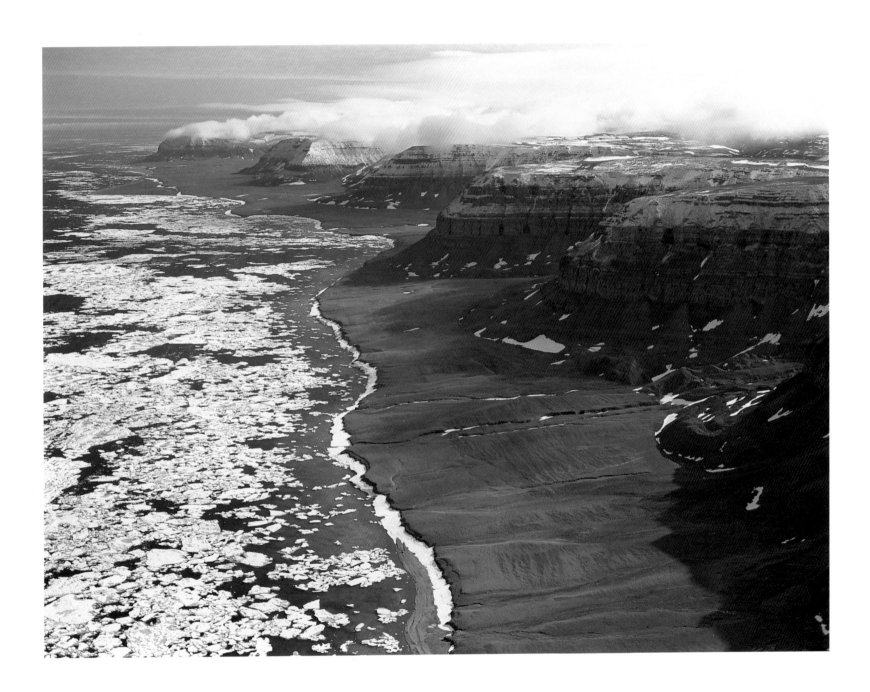

The coastal mountains and valleys of the Brodeur Peninsula as they meet the edge of Lancaster Sound, Baffin Island.

Because mankind can circumvent evolutionary law, it is incumbent upon him . . . to develop another law to abide by if he wishes to survive, to not outstrip his food base. He must learn restraint. He must derive some other, wiser way of behaving toward the land. He must be more attentive to the biological imperatives of the system of sun-driven protoplasm upon which he, too, is still dependent. Not because he must, because he lacks inventiveness, but because herein is the accomplishment of the wisdom that for centuries he has aspired to. Having taken on his own destiny, he must now think with critical intelligence about where to defer.

A small stream flowing from one of the numerous valleys along the north shore of the Brodeur Peninsula.

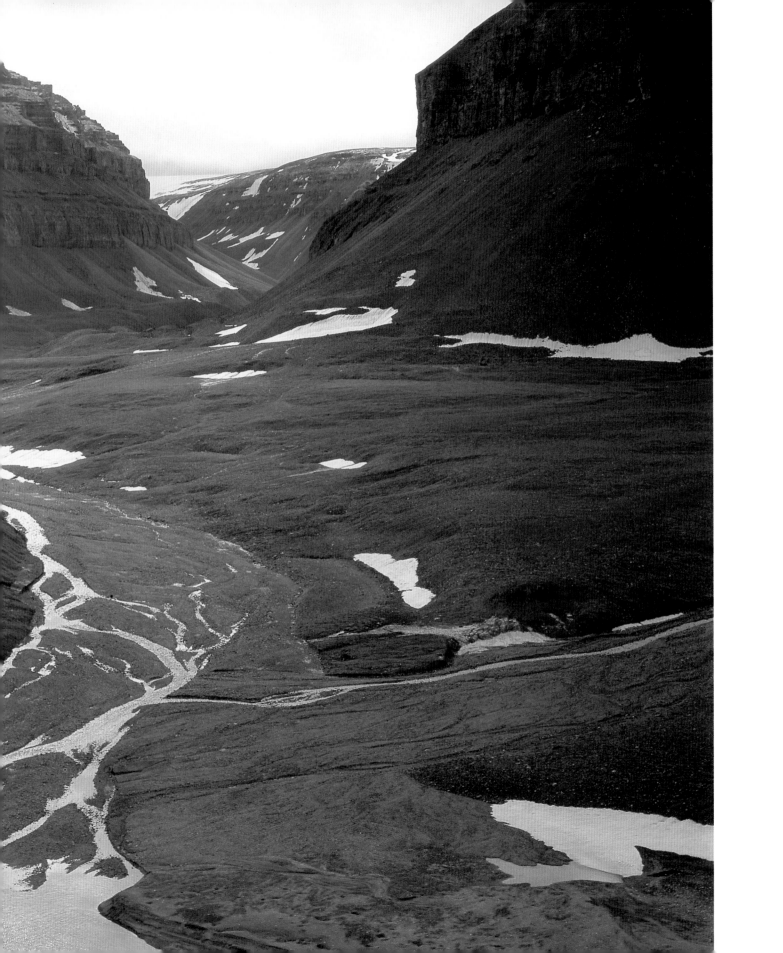

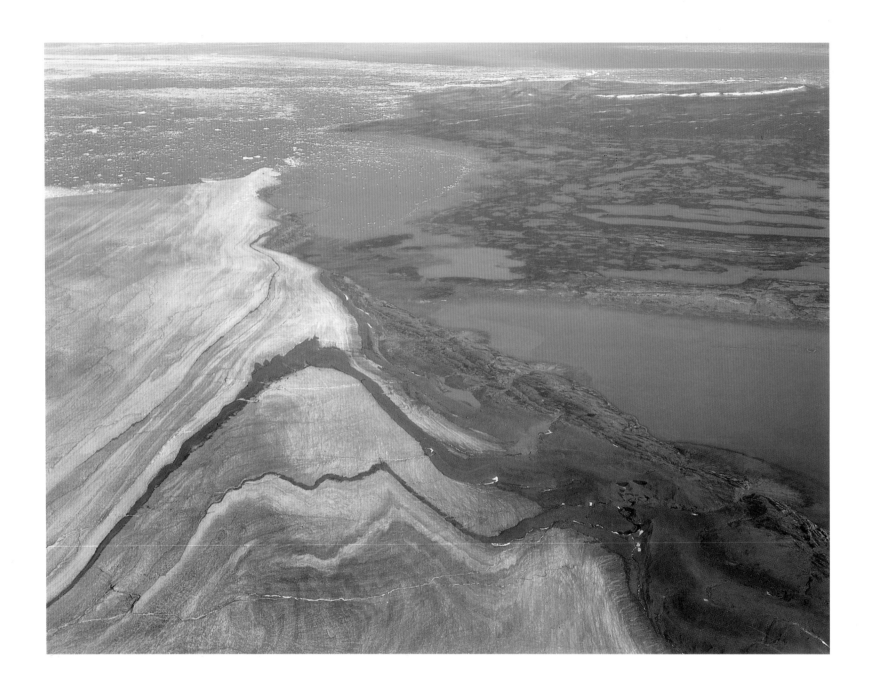

A glacier reaches tidewater, Devon Island.

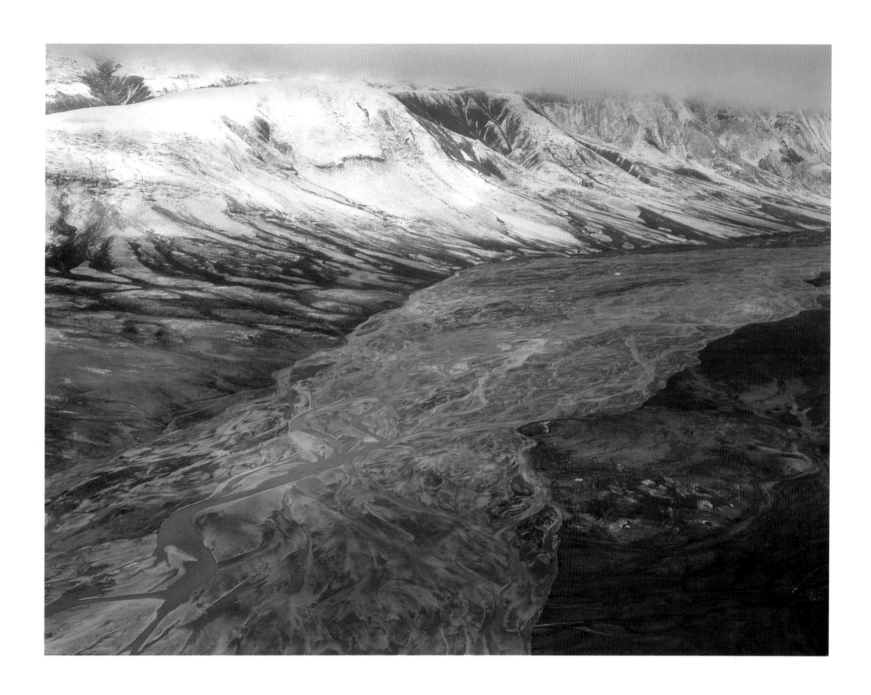

A light August snow dusts the mountains above a broad and seasonally dry riverbed near the head of Otto Fjord, Ellesmere Island.

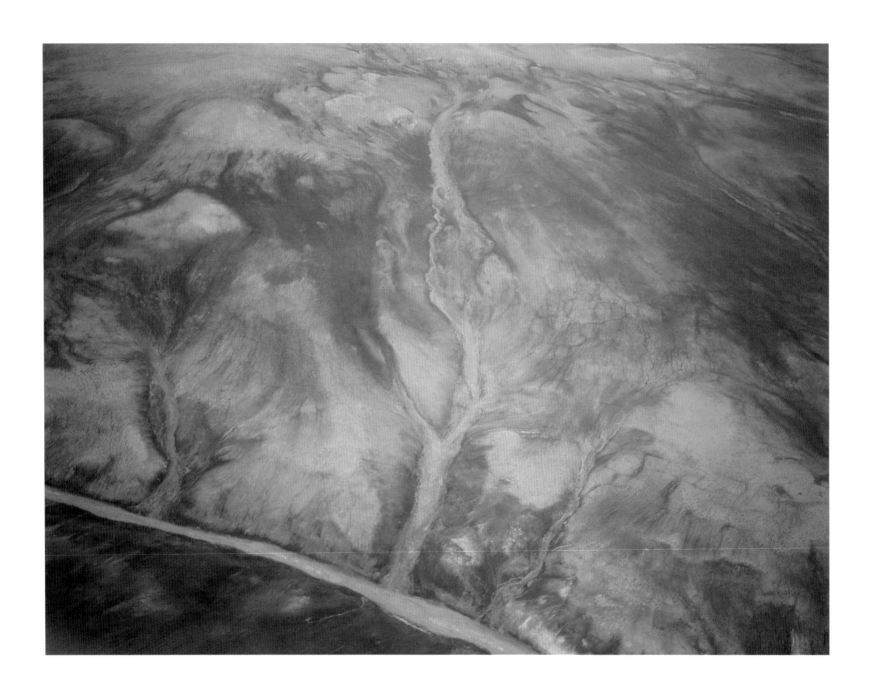

Dry river valleys and lichen-covered hills, north of Resolute, Cornwallis Island.

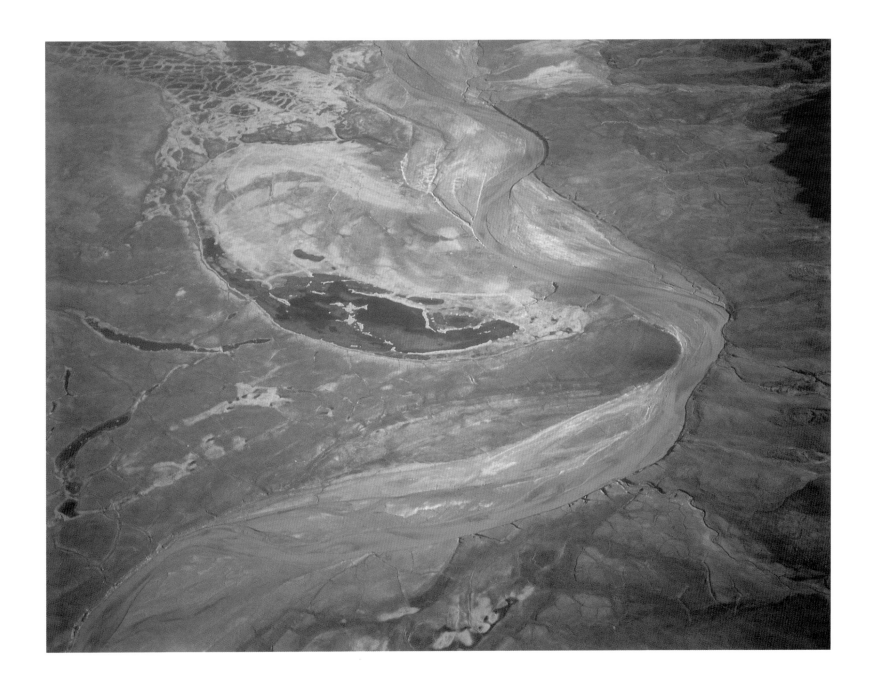

A large river system, Ellesmere Island.

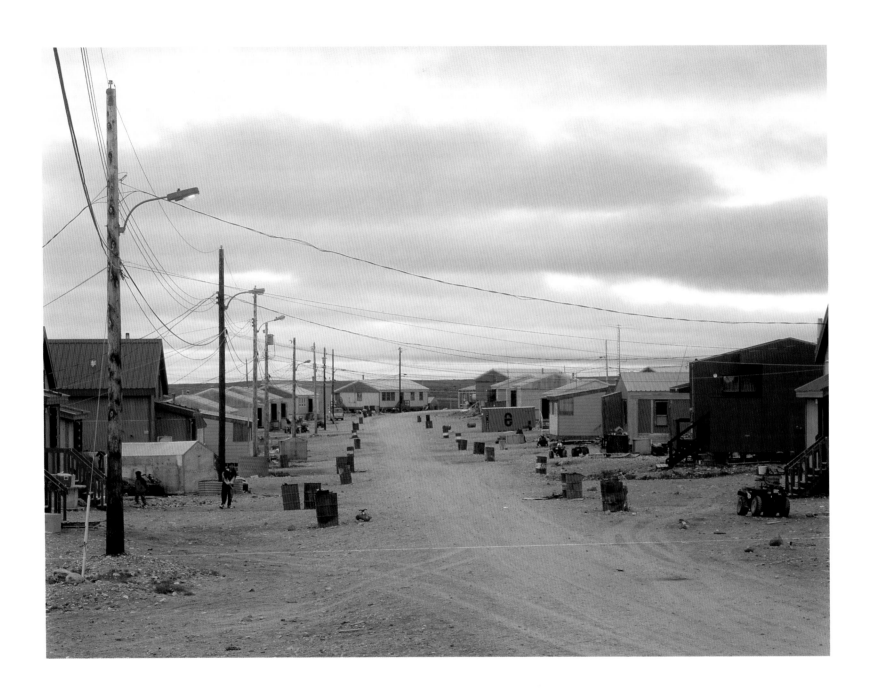

The Inuit village of Gjoa Haven, Northwest Territories, Canada.

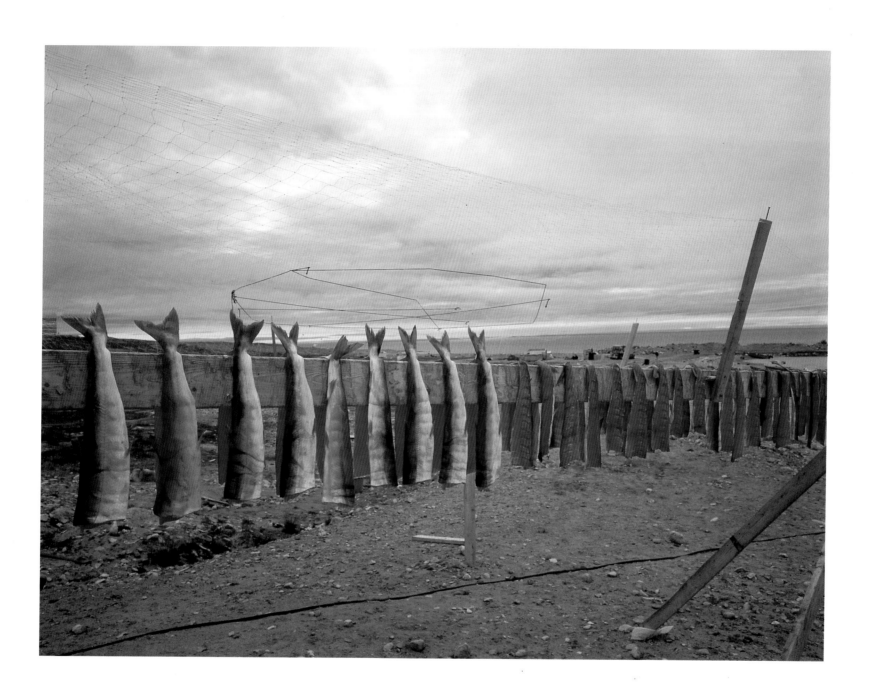

Arctic char being air-dried in the traditional Inuit way, Gjoa Haven.

{With Eskimos,}...one feels the constant presence of people who know something about surviving. At their best they are resilient, practical, and enthusiastic. They pay close attention in realms where they feel a capacity for understanding. They have a quality of nuannaarpoq, *of taking extravagant pleasure in being alive; and they delight in finding it in other people. Facing as we do our various Armageddons, they are a good people to know.*

The beautiful Greenland village of Sisimiut (Holsteinsborg), built into the rock walls of a fjord.

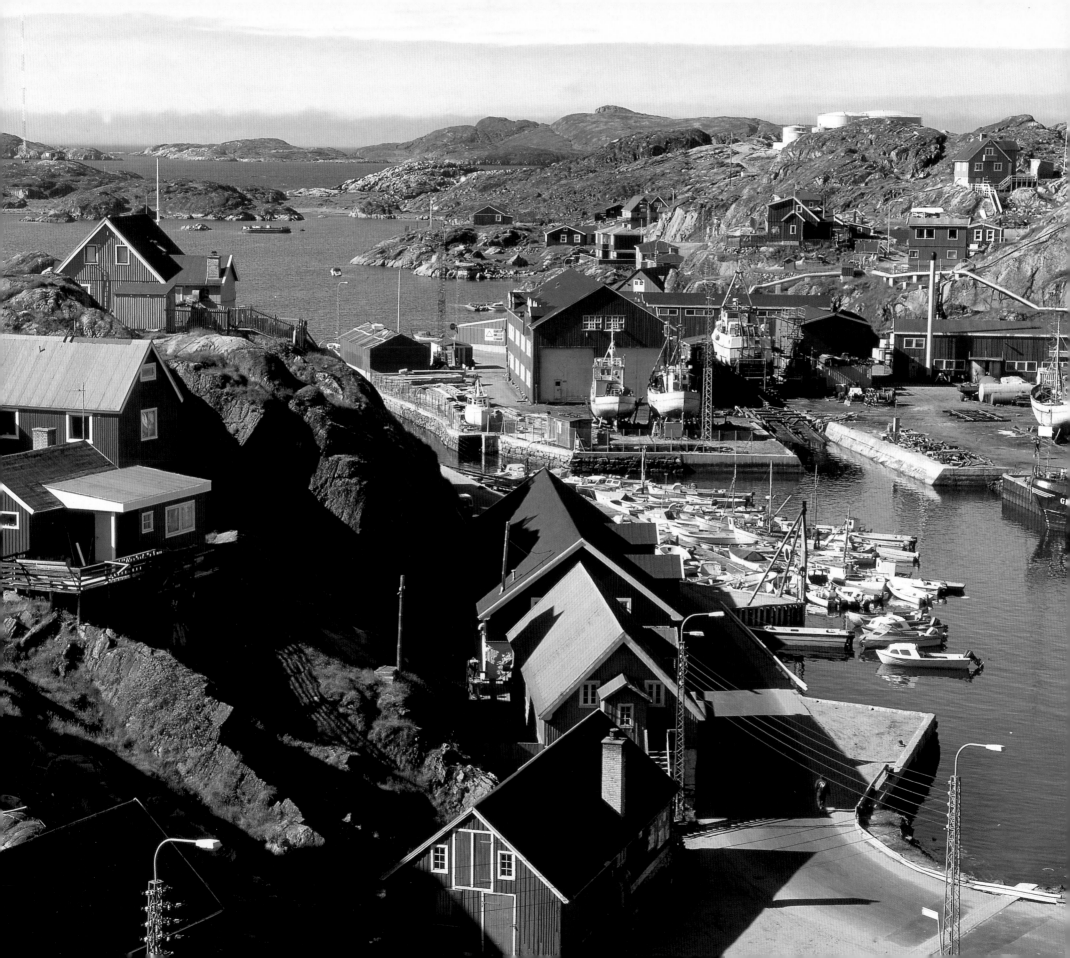

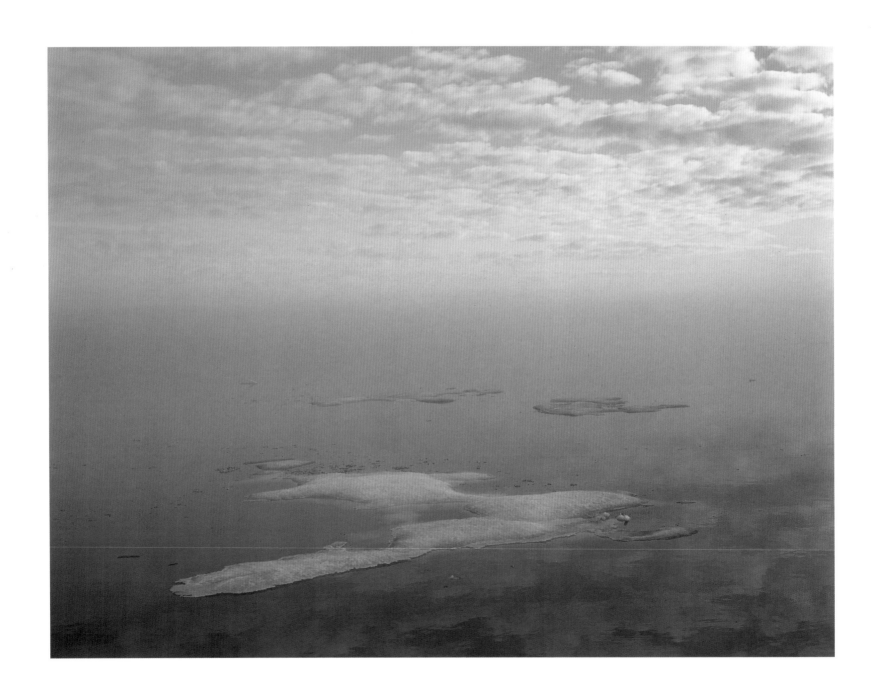

"Navigation Without Numbers"/Homage to Wynn Bullock.

The **Itasca** *offshore of Somerset Island, waiting for the fog-delayed inbound helicopter.*

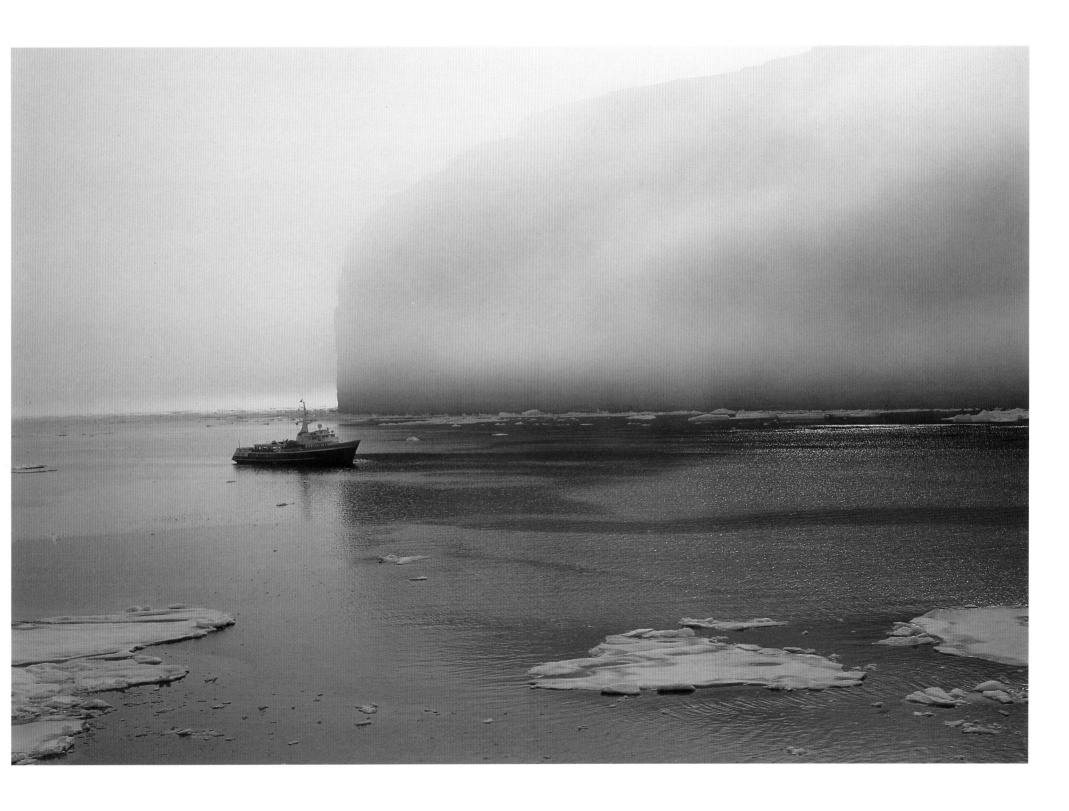

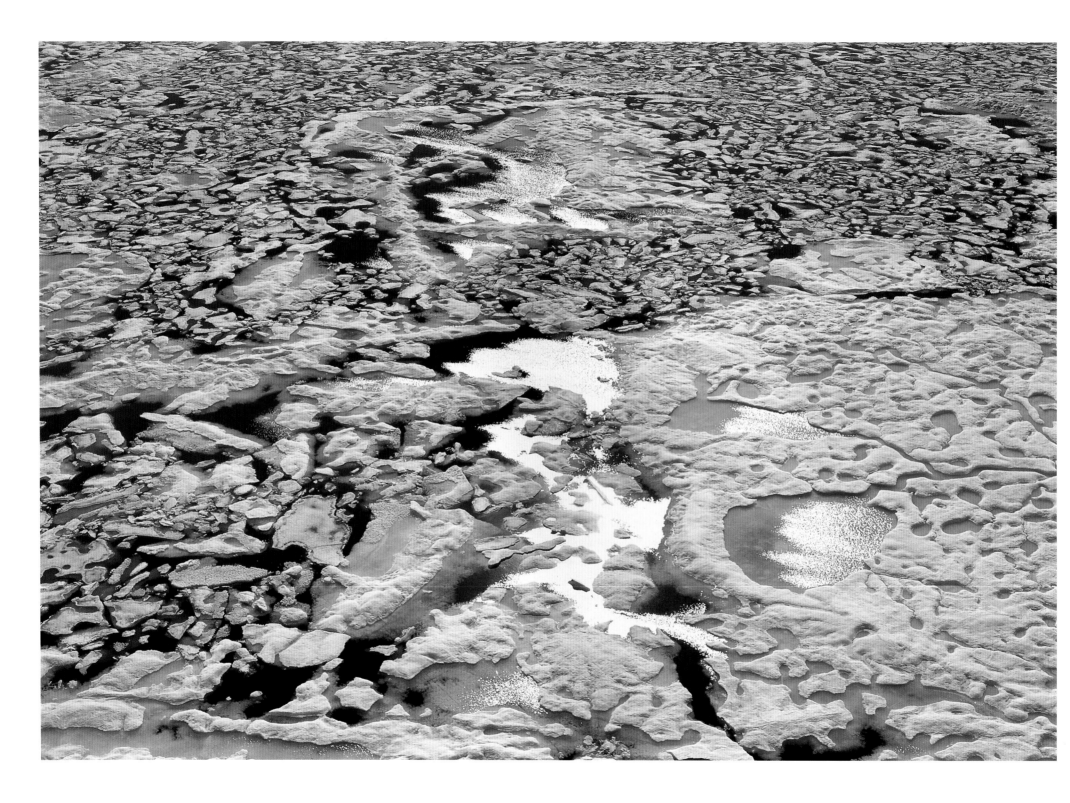

Open ocean and rainwater pools reflect the sun's glare, Larsen Sound.

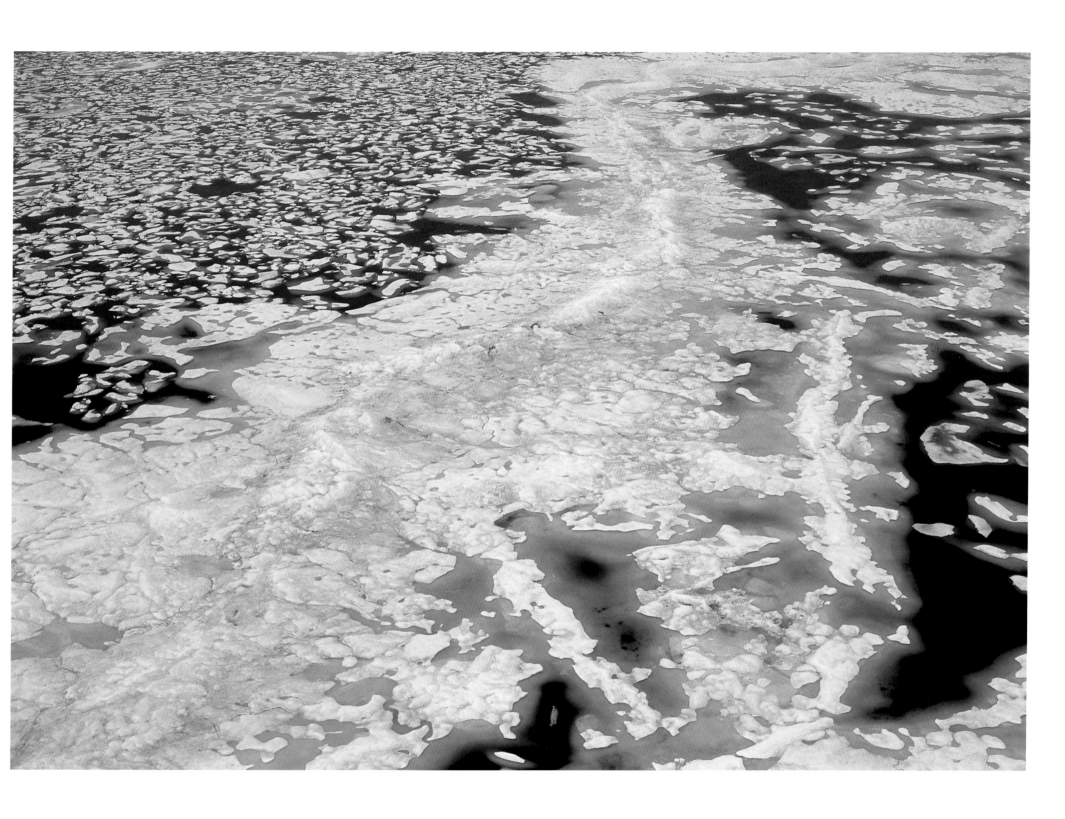

A pressure ridge, created by the collision of two huge ice fields, drifts in the open ocean. These ridges can be many miles in length, like a small mountain range of ice.

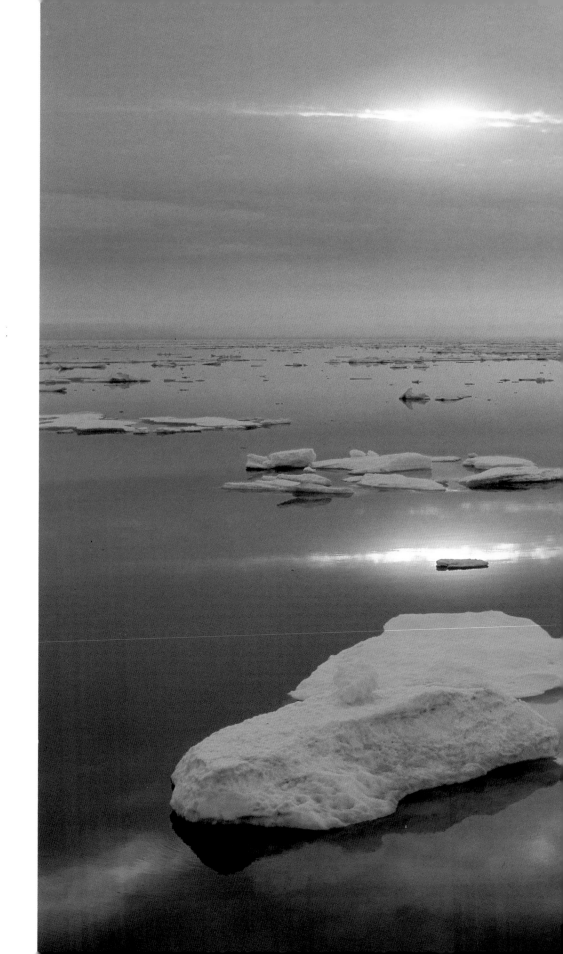

I looked up at the icebergs. They so embodied the land. Austere. Implacable. Harsh but not antagonistic. Creatures of pale light. Once, a friend had said, gazing off across a broad glacial valley of soft greens and straw browns, that it was so beautiful it made you cry. . . . I looked out at the icebergs. They were so beautiful they also made you afraid.

Dead-calm sunset before the storm, Larsen Sound.

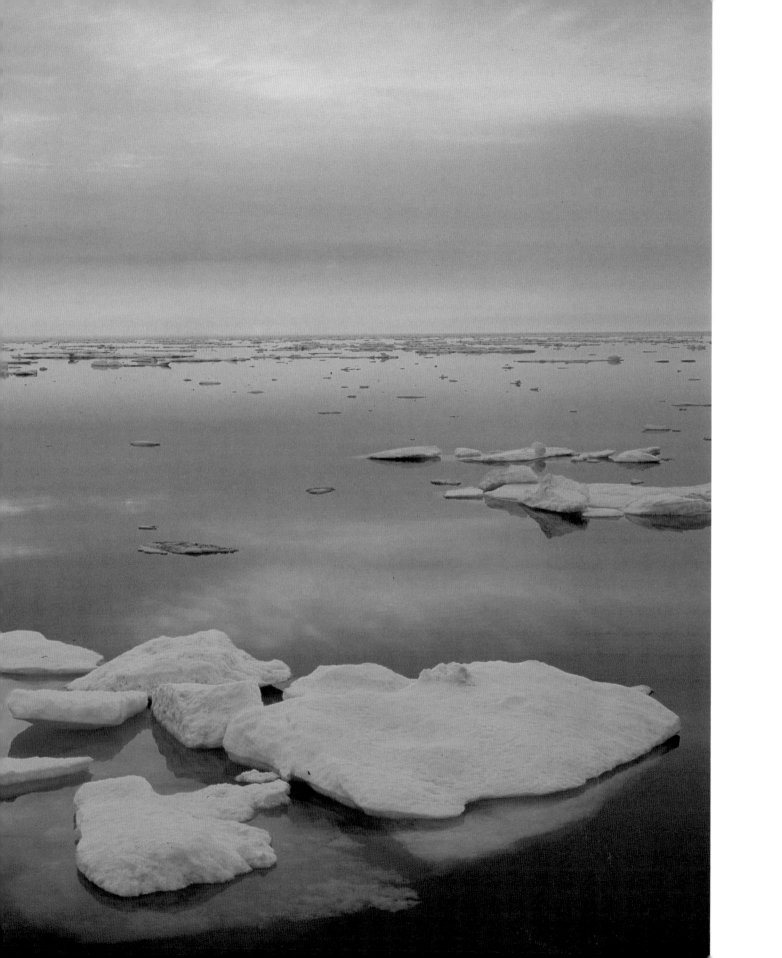

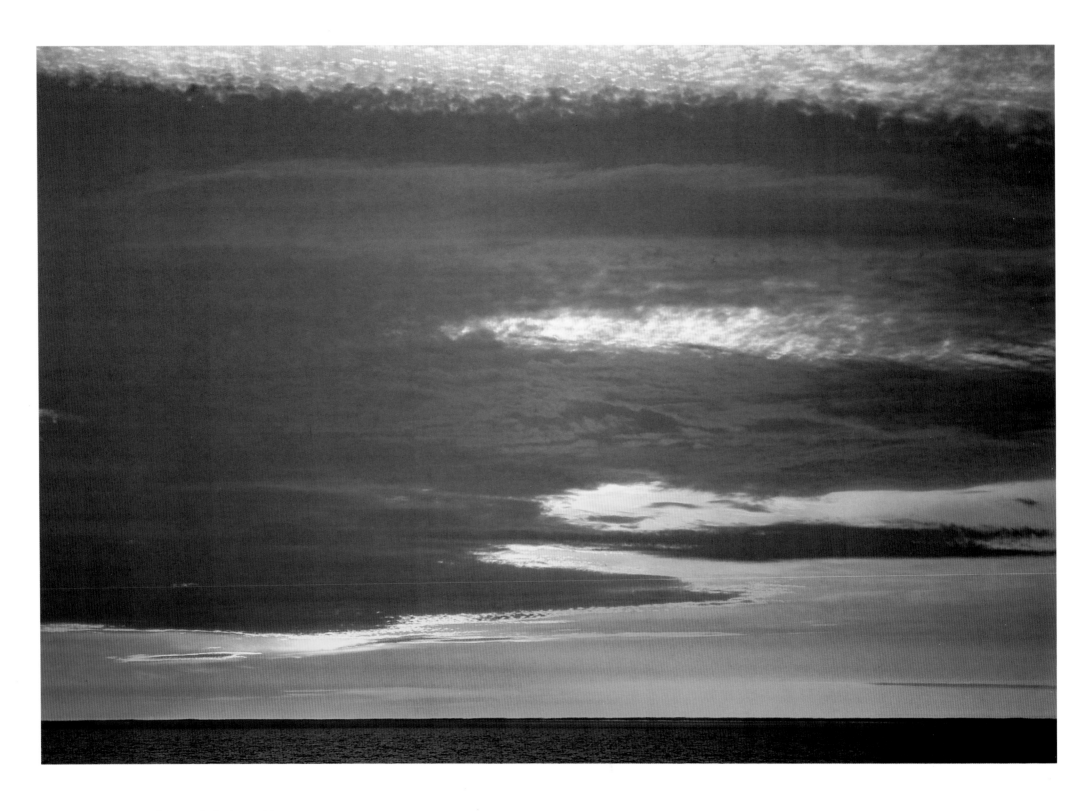

Stay tuned, sky show at 11 P.M.

Incoming cirrus clouds above clearing weather, indicating imminent changes, Larsen Sound.

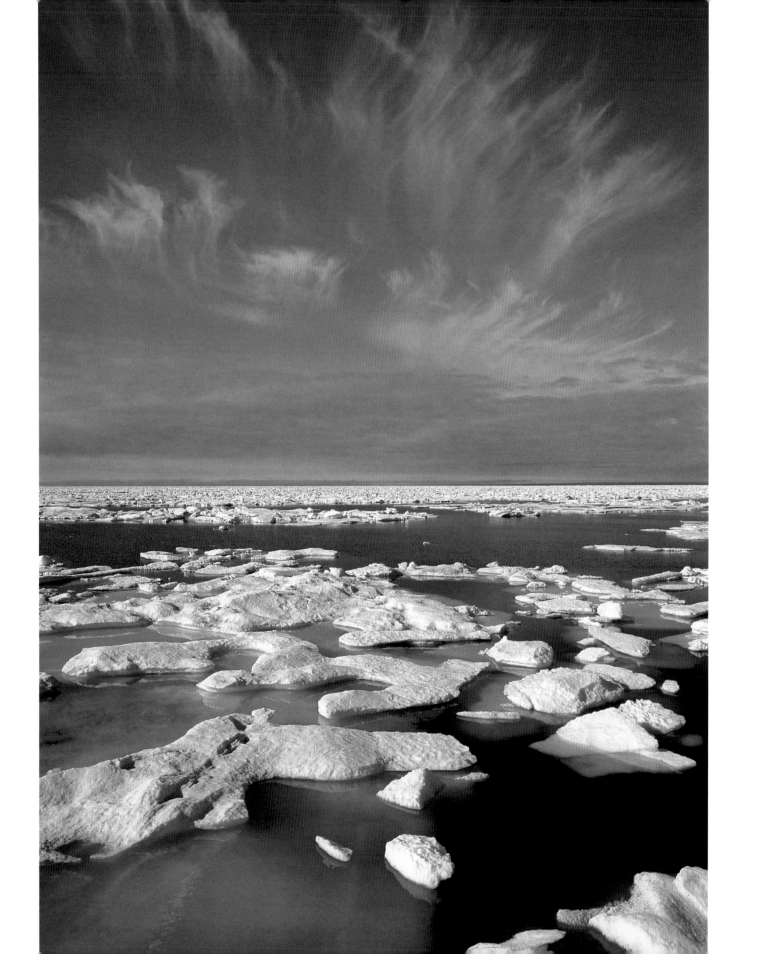

American landscape painting in the nineteenth century…reveals a struggle with light and space that eventually set it apart from a contemporary European tradition of pastoral landscapes framed by trees, the world viewed from a carriage window. American painters meant to locate an actual spiritual presence in the North American landscape…. The atmosphere of these paintings is silent and contemplative. They suggest a private rather than a public encounter with the land. Several critics… have described as well a peculiar "loss of ego" in the paintings. The artist disappears. The authority of the work lies, instead, with the land. And the light in them is like a creature, a living, integral part of the scene. The landscape is numinous, imposing, real….

Vertical, lichen-covered shoreline of Bylot Island.

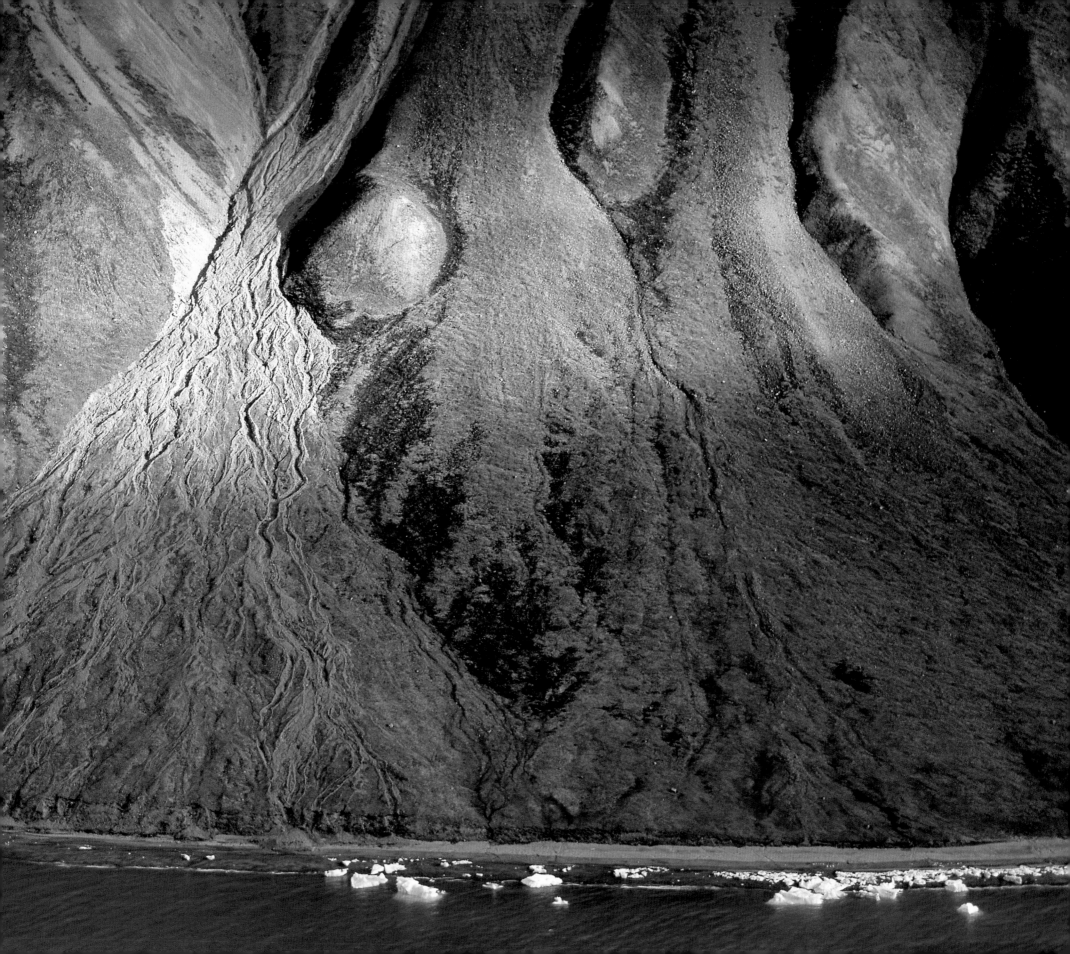

ACKNOWLEDGMENTS

I have always wanted to see the worlds that exist at the earth's poles—and, as the lesser-explored of the two, the Arctic interested me most. In many people's minds, the Arctic is envisioned as icy and austere, but in reality, there is much more. Unlike Antarctica, it is not covered by an ice cap, so it thaws out every summer, which allows for a substantial animal population, including the largest land predator still in existence, the polar bear. The waters there are filled with a myriad of fish, seals, walrus, and an extraordinary diversity of whales. Birds flock here as well, to feed and raise their young. Many scientists believe that the Arctic oceans may be the richest of all breeding grounds on the planet.

The Arctic is a spare, magnificent place, eloquently described by Barry Lopez in his book *Arctic Dreams*. His words further inspired my growing desire to travel there and best depict the richness of this place that many of us perceive as barren. I would like to thank Barry for allowing us to excerpt passages from *Arctic Dreams* for this book.

Getting there was unquestionably the most complicated part. It was finally accomplished through the efforts of many people, all of whom I would like to thank. First and foremost is William Simon, Sr., businessman, adventurer, former United States Secretary of the Treasury, and patron of this expedition. It was his foresight, desire, generosity, and unwavering commitment to the success of this voyage that made the passage possible. He built our ship, the *Itasca*, which stood up to every test and still provided all of us with great comfort. He hired a hard-working and personable crew, and brought together a very interesting group of guests—we became a true team. All of this was essential to the trip's success.

While he may not have realized it, Bill provided me with an observation platform that is probably unprecendented in Arctic history: the daily use of the *Itasca's* on-board helicopter, and the ship's ever-changing location. For me, the images in this book constitute a tremendous leap forward in my work.

Captain Alan Jouning and his crew—first mate Colin McKay, Peter Welsh, David Rassmussen, Hector Arcio, Max Cumming, Greame Vallely, Mark Cressey, Herb Myers, Julie Plummer, Barbara Khul, Jody Crump, and Kurt Doldinger—were amazing to watch as they worked round the clock. Eternally helpful, gracious, able to make any repair while underway, and good comrades, they cared for us all under some trying conditions.

As each of the guests has already been identified in Bill's preface, I will simply say that without them the adventure would have been much less fun, and I appreciate their many insights, which informed my work. I would also like to thank George and Marsha Gowen, who have been my friends for years, and who recommended me to Bill as the photographer for this voyage.

Patagonia generously provided the gear for the voyage. Not only is their clothing and equipment indispensible for adventuring, they have an exemplary corporate mentality, which expresses their serious commitment to the environment. Thank you.

As they have for many years, Pentax provided support in the form of their medium-format (645 and 6 x 7) camera systems, which were especially suited to the rigors of this journey. The Pentax 645 is the finest piece of hand-held equipment I have ever worked with, and the photographs in this book could not have been made without it.

To minimize handling and preserve my original transparencies for printmaking, this book has been reproduced from duplicates. The duplicates were the technical accomplishment of Mario Gomez and his staff at A & I Color Labs in Los Angeles, to whom I am grateful for their excellent work.

Neither the book nor the exhibition would have been possible without the generous support of the Lund Foundation, the California Community Foundation, the Olin Foundation, and several other donors who choose to remain anonymous.

Finally, I'd like to thank the staff at Aperture: Michael Hoffman, for allowing me the freedom to participate in this creation; Diana Stoll, my editor, for overseeing my words and deadlines; Steve Baron, for his tireless dedication to quality printing; and Roger Gorman, whose designs in this and other books of my work have done so much to enhance the presentation of my images.

The Arctic is a fragile and demanding ecosystem that represents about 20 percent of the earth's total land surface. Given its size and importance, it is deserving of much greater public and political attention. This is more true now than ever, as the Arctic environment is presently in great peril. As remote as it is, the Arctic has always been a target of exploitation. That exploitation has now intensified because of large-scale, careless development that is potentially devastating.

The quest for minerals, oil, and gas reserves not only threatens an ecosystem that is easily disturbed, but it also places indigenous people at risk. Development depends on land ownership and, as in Alaska, native corporations—made "owners" by law and legislation—are easily manipulated to "manage" their lands for profit. Often, when wild land is opened to exploitation, fish and wildlife areas that have supported villages become seriously impaired.

As areas are developed, new roads and transportation technologies make the resource-harvest more efficient, but at the same time they poison or destroy the greater habitat. Increased efficiency of harvest also threatens marine fisheries. Industrial trawlers using drift-nets catch enormous volumes of fish—overfishing the stock. This method also claims hundreds of thousands of other, noncommercial fish as "by-catch," which are thrown back dead, depleting ocean resources that feed all of the other animals.

Perceived as out of the public eye by regional governments, the Arctic has become a dumping ground for industrial nations. Russia in particular threatens the Arctic Ocean, as Russian rivers flowing to it carry so much industrial waste. Cadmium, nickel, and PCBs seem to be collecting in the fat tissue and kidneys of Arctic animals, and despite the London Convention to ban ocean disposal of all radioactive matter, the present Russian government still uses the Arctic Ocean waters to dispose of radioactive waste. Plutonium from the English Sellafield plant is also delivered to the Arctic by ocean and wind currents.

Atmospheric currents in the Northern Hemisphere carry the pollution of industrial nations north toward the pole, where it is rained back down onto the ground and into the ice. Trace elements, persistent organic compounds, and radioactive materials are then passed along the food chain, eventually reaching native populations. Canada has issued warnings about excessive concentrations of pollutants in the bodies of certain animals and fish that are among the traditional subsistence foods of indigenous peoples, and researchers have recently become alarmed at the levels of PCBs in the milk of nursing native mothers.

Lastly, increased ultraviolet radiation, caused by the thinning of the ozone layer, places Arctic life forms at particular risk. Canadian scientists already recognize that in the long days of spring and the perpetual light of summer, exposure exceeds recommended health levels, but their research also suggests something far more ominous. Ultraviolet rays have been measured that penetrate sixteen meters into the ocean, where they may be affecting the bottom of the food chain, and will certainly have some impact on the larger marine mammals who have never had such exposure.

More than any other region of the planet, the Arctic demonstrates that the natural world knows no international boundaries. The fish populations that feed and breed there migrate from all the oceans of the world. The birds do so as well, some traveling from as far as South America and Antarctica. The caribou herds and polar bear are also transboundary by nature, often migrating thousands of miles. And, dependent on certain species for survival, the people themselves have been traditionally nomadic as well.

With pressure from many sides for more resource development, those that might defend this environment are fragmented and fractionalized. The nations of the world defer responsible management with smoke screens of unresolved treaties, while allowing multinational corporations to operate without serious enforcement of environmental regulation.

The Arctic is by no means a barren wasteland that should be sacrificed thoughtlessly. Both politically and otherwise, it deserves more of our attention, concern, and appreciation.

Aperture gratefully acknowledges generous contributions from the Lund Foundation, the California Community Foundation, the Olin Foundation, and other donors who choose to remain anonymous. Their kind support made this project possible.

Prints of *Dead calm sunset before the storm, Larsen Sound* (pages 88–89) are available through Aperture in a limited edition of 50 numbered prints and 10 artist's proofs, on 16-by-20-inch paper, signed by Robert Glenn Ketchum.

An exhibition of the work in *Northwest Passage* is traveling in the United States, and will appear at the Alinder Gallery in Gualala, California in the Fall of 1996, and at the George Eastman House in Rochester, New York in the Summer of 1997.

Library of Congress Catalog Card Number: 96-83974

Hardcover ISBN: 0-89381-676-0
Paperback ISBN: 0-89381-693-0

Book and jacket design by Roger Gorman, Reiner Design, NYC
Printed and bound by Sfera International Srl., Milan, Italy

The staff at Aperture for *Northwest Passage* is:
Michael E. Hoffman, Executive Director
Diana C. Stoll, Editor
Ron Schick, Executive Editor
Stevan A. Baron, Production Director
Helen Marra, Production Manager
Michael Lorenzini, Assistant Editor
Nina Hess, Amy Schroeder, Editorial Work-Scholars
Meredith Hinshaw, Production Work-Scholar

Aperture publishes a periodical, books, and portfolios of fine photography to communicate with serious photographers and creative people everywhere. A complete catalog is available upon request. Address: 20 East 23rd Street, New York, New York 10010. Phone: (212) 598-4205, toll-free (800) 929-2323. FAX: (212) 598-4015.

First edition
10 9 8 7 6 5 4 3 2 1